D1315929

DESIGNING WITH ONE COLOR AND TWO COLORS

MAIA FRANCISCO

DESIGNING WITH ONE COLOR AND TWO COLORS

MAIA FRANCISCO

HARPER
DESIGN

An Imprint of HarperCollins Publishers

DESIGNING WITH ONE COLOR AND TWO COLORS
Copyright © 2011 by Harper Design and **maomao** publications

All rights reserved. No part of this book may be used or reproduced in any manner whatsoever, without written permission except in the case of brief quotations embodied in critical articles and reviews. For information, address Harper Design, 10 East 53rd Street, New York, NY 10022.

HarperCollins books may be purchased for educational, business, or sales promotional use. For information, please write: Special Markets Department, HarperCollins*Publishers*, 10 East 53rd Street, New York, NY 10022.

First Edition:
Published by **maomao** publications in 2011
Via Laietana, 32 4th fl., of. 104
08003 Barcelona, Spain
Tel.: +34 93 268 80 88
Fax: +34 93 317 42 08
www.maomaopublications.com

English language edition first published in 2011 by:
Harper Design
An Imprint of HarperCollins*Publishers*,
10 East 53rd Street
New York, NY 10022
Tel.: (212) 207-7000
Fax: (212) 207-7654
harperdesign@harpercollins.com
www.harpercollins.com

Distributed throughout the world by:
HarperCollins*Publishers*
10 East 53rd Street
New York, NY 10022
Fax: (212) 207-7654

Publisher: Paco Asensio

Editorial Coordination: Anja Llorella Oriol

Editor: Maia Francisco

Introduction & Text: Maia Francisco, Cristian Campos

Translation: Cillero & de Motta

Art Direction: Emma Termes Parera

Layout: Maira Purman

Cover Design: Emma Termes Parera

ISBN: 978-0-06-200461-1

Library of Congress Control Number: 2010941621

Printed in Spain
First Printing, 2011

The PANTONE colors were specified by each designer and reflect how the projects were originally printed, but not how they have been reproduced in this book. The images in this book have been printed using the PANTONE COLOR BRIDGE® Coated guide which shows the best possible four-color process simulation on coated stock of the original solid PANTONE Color being identified above each image. Due to the printing process and paper stock variables, the colors may vary accordingly from the designer's initial projects.

PANTONE Colors displayed here may not match PANTONE-identified standards. For accurate PANTONE Color Standards, refer to current PANTONE Color Publications. To purchase or receive more information about PANTONE Products go to www.pantone.com. PANTONE® and other Pantone trademarks are the property of Pantone LLC. Portions © Pantone LLC, 2010. All rights reserved. Pantone's trademarks and copyrights used with the permission of Pantone under License Agreement with **maomao** Publications.

DESIGNING WITH TWO COLORS

Why is it that if a designer can choose two colors for a design, a great many of them usually go for black as one of them? Why not choose two bright colors, like red and yellow, for example? The reader will find the answer in the following pages, but they will also come across examples to the contrary, of two-tone designs that dispense with black and opt for more daring combinations. The evocative power of the combination of certain colors (for example, using red and yellow to reflect the Chinese flag) is a useful resource when designers need to overcome the language barrier and make it easier for people all over the world to understand a specific design.

PANTONE YELLOW 012 C

ZentralSchwei

Freitag 13. März, 20.00 Uhr: Emil Steinberger liest und erzählt

zer Literatur

Samstag 14. März, 10.15 Uhr: Prominente Gäste im Gespräch. Marco Meier, Andreas Iten

tage 2009

Samstag 14. März, 13.30 Uhr: Sechs Lesungen

Samstag 14. März, 20.00 Uhr: Szenische Lesung. Kurzgeschichtenwettbewerb

13. bis 15. März,

Sonntag 15. März, 10.00 Uhr: Lyrik Matinee

Sonntag 15. März, 12.30 Uhr: Vier beste Bücher. Literaturkritik

Stadtmühle

Willisau

www.stadtmuehle.ch / www.issv.ch

Literaturtage 2009 ı Niklaus Troxler. This poster presents the information for Literaturtage 2009 by combining differently sized fonts. Some of the texts are highlighted by bands of yellow similar to those made by a Stabilo Boss felt tip pen.

PANTONE BLACK C

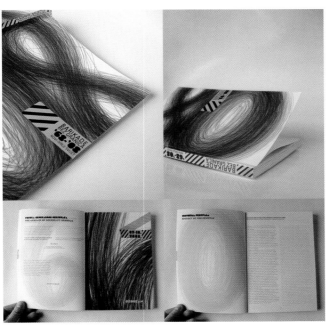

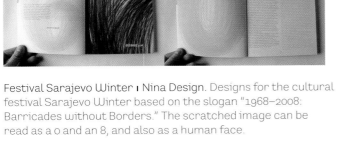

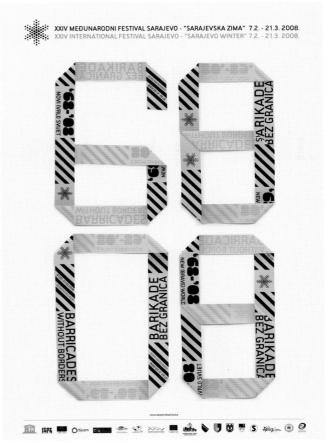

Festival Sarajevo Winter ı Nina Design. Designs for the cultural festival Sarajevo Winter based on the slogan "1968–2008: Barricades without Borders." The scratched image can be read as a 0 and an 8, and also as a human face.

PANTONE 108 C

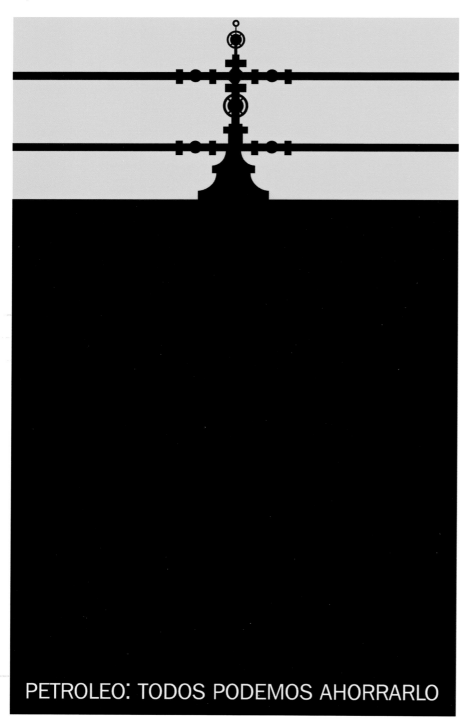

PETROLEO: TODOS PODEMOS AHORRARLO

PANTONE BLACK C

Petróleo ı Félix Beltrán. The black slick in this protest poster symbolizes the oil the viewer is urged to save. The viewer only reads the text in the slogan at the foot of the poster after running their eye from top to bottom, moving from yellow to black and finally to white.

Adrian Shaughnessy:
The design consultant & writer on this year's
Design entries

D&AD Awards Gala 2008 ı Studio 8 Design. For this leaflet for the
charity organization D&AD, whose aim is to promote excellence
in artwork and design, iconic images and illustrations were used
along with a single color. The different fonts break up the visual
monotony.

PANTONE 116 C

PANTONE BLACK C

2008
Jury List

AMBIENT

ART DIRECTION

BOOK DESIGN

BRANDING

BROADCAST INNOVATIONS

DIGITAL INSTALLATIONS

DIRECT

ENVIRONMENTAL DESIGN

GAMING

GRAPHIC DESIGN

ILLUSTRATION

INTEGRATED

Welcome:
D&AD President Simon Waterfall

Welcome to D&AD's 45th Awards Ceremony and for the first time to the Royal Festival Hall. What a night we have before us – two Simons, a number of costume changes and of course the best work in the world. For us it's all about the work, for us to find it and then tonight to celebrate it.

Chosen from over 25,000 entries these 143 nominations split over 30 juries judged by 304 of our peer group, many of whom are here, is the result of the most rigorous selection process around – the judges put themselves through hell at ExCeL in April, in their individual search for excellence, and I owe them a massive thank you.

Thanks are also due to our sponsors, Adobe, Channel 4 and You Tube without whose support we would not be able to fulfil our commitment to championing creative excellence – both present and future.

D&AD is committed to nurturing the next generation of creative talent and in the audience tonight we have a number of D&AD 2007 Student Award winners – so look out for ironic fashion statements and bad haircuts as underneath lurks your next and best hire, grab them tonight they truly are winners.

All that remains is for me to thank you for being here and to wish you a wonderful night, it's a cliché to say that all nominations are winners, but in D&AD's case its true, having won one in my life I know it's a special year when your work cuts through at this global level. It's not luck, but hard work that's got us all here tonight.

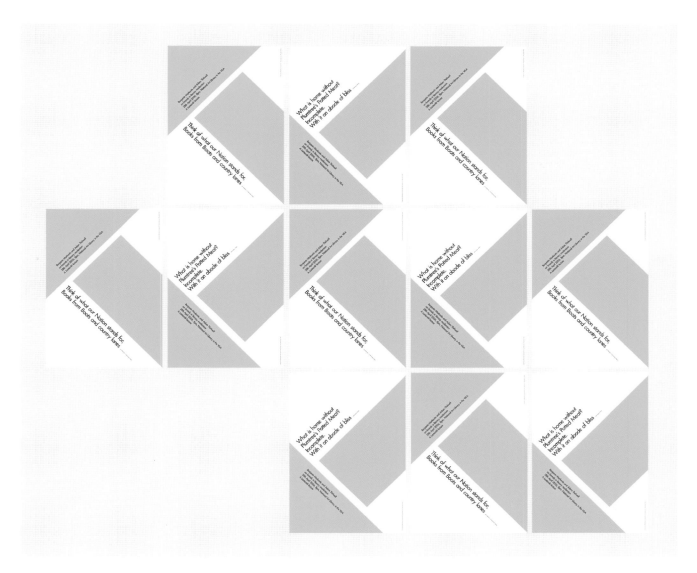

Lantern Lit/V&A posters ı Studio 8 Design. This series of posters form a geometric web and promote a conference of Lantern Lit at the National Art Library. The texts, arranged diagonally to the geometric shapes, can be read without any problem, either against the yellow background or the white.

PANTONE 116 C

PANTONE BLACK C

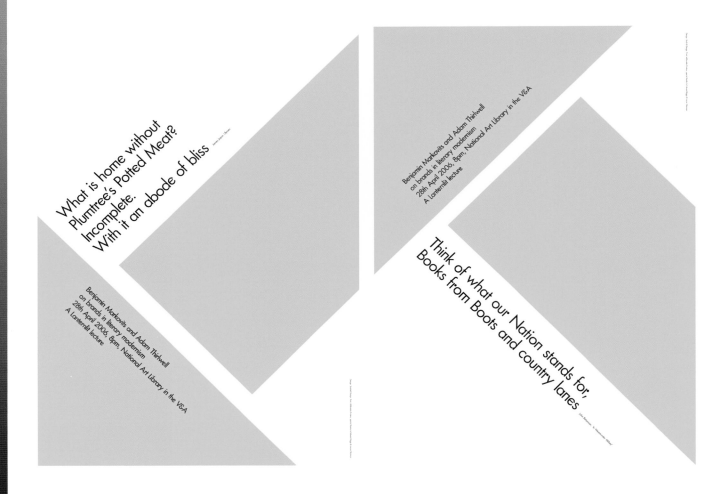

What is home without
Plumtree's Potted Meat?
Incomplete.
With it an abode of bliss

James Joyce, Ulysses

Benjamin Markovits and Adam Thirlwell
on brands in literary modernism
28th April 2006, 8pm, National Art Library in the V&A
A Lanternfill lecture

Benjamin Markovits and Adam Thirlwell
on brands in literary modernism
28th April 2006, 8pm, National Art Library in the V&A
A Lanternfill lecture

Think of what our Nation stands for,
Books from Boots and country lanes

John Betjeman, In Westminster Abbey

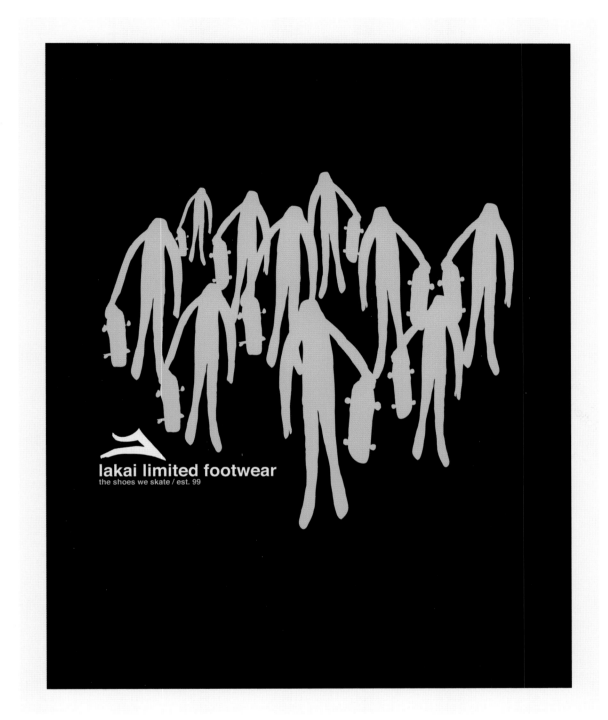

Lakai Limited Footwear poster ı OhioGirl Design (Andy Mueller).
In keeping with all the other promotional designs done by OhioGirl
Design for the Lakai brand, this poster features a minimalist use
of color.

PANTONE 123 C

PANTONE BLACK C

pinebender things are about to get weird

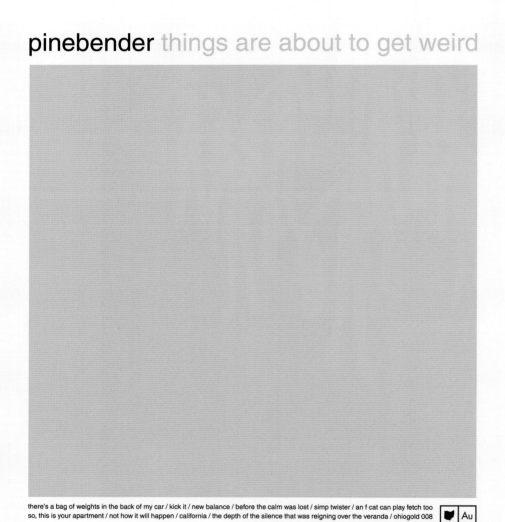

there's a bag of weights in the back of my car / kick it / new balance / before the calm was lost / simp twister / an f cat can play fetch too
so, this is your apartment / not how it will happen / california / the depth of the silence that was reigning over the veranda / ohiogold 008
ohiogold / p.o. box 25441 / chicago illinois usa 60625-9998

Pinebender CD cover ı OhioGirl Design (Andy Mueller). Avoiding
the usual baroque style often found in the design of CD covers
for pop and rock bands, OhioGirl Design opted for a simple yellow
square set off with the band's name in black, and that of the CD
appearing in yellow against a white background.

PANTONE 125 C

Deutsche Akademie
für Sprache und Dichtung
Frühjahrstagung 2009
21.–24. Mai in Berlin

Arnold Stadler Daniel Kehlmann
Felicitas Hoppe Brigitte Kronauer
Josef Winkler Barbara Honigmann
Lutz Seiler Peter Hamm Ingo Schulze
Heinrich Detering Wilhelm Genazino

Deutsche
Akademie
für
Sprache
und
Dichtung

Deutsche Akademie für Sprache und Dichtung ı Rosagelb. This
flyer was created for the German Academy of Language and
Poetry. The designers chose to use the colors brown and black
to represent modesty and pragmatism, the academy's founding
principles. The names that appear on the document are those of
the members of the academy.

PANTONE BLACK C

PANTONE 457 C

PANTONE BLACK C

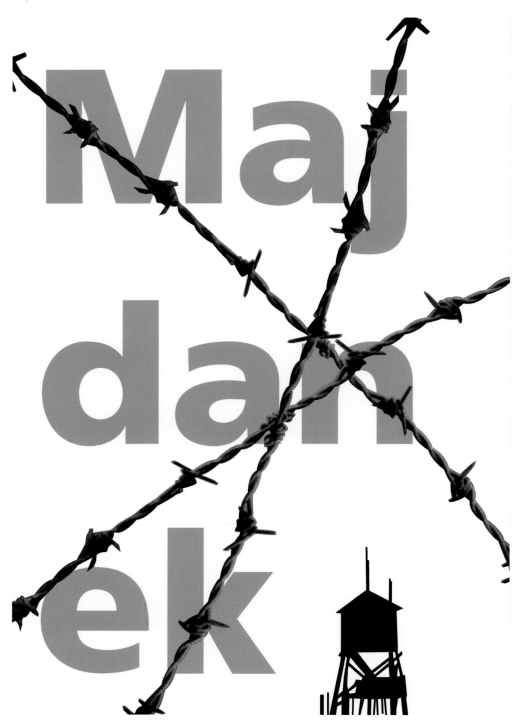

Majdanek ı Richard B. Doubleday. A shade of yellow was used to
divide this poster for the Majdanek Art Triennial into two different
levels. The sense of depth obtained by doing this would be
impossible to achieve by just using black on a white background.

PANTONE 605 U

PANTONE 439 U

on
differ
ence #2
grenzwertig

18.02. – 30.04.2006

On Difference #2: Grenzwertig
Württembergischer Kunstverein Stuttgart
Schlossplatz 2, D–70173 Stuttgart
Öffnungszeiten: Di, Do–So: 11–18 Uhr, Mi: 11–20 Uhr
Telefon: +49 (0)711–22 33 70, Fax: +49 (0)711–29 36 17, www.wkv-stuttgart.de

On Difference ı L2M3 Kommunikationdesign (Sascha Lobe, Dirk Wachowiak). In this poster announcing a group exhibition at the Württembergischer Kunstverein in Stuttgart (Germany), the text has been playfully deconstructed to produce an intriguing mirror-image effect that breaks up the symmetry and reflects the show's concept, "On Difference."

PANTONE 803 C

PANTONE BLACK C

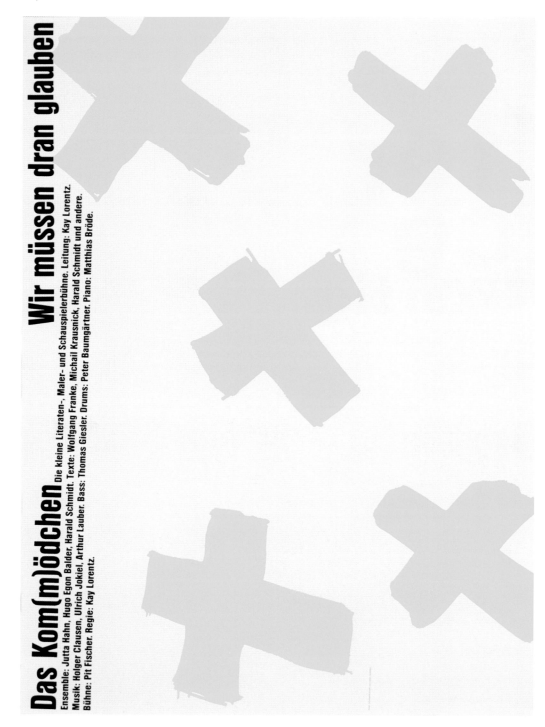

Das Kom(m)ödchen Die kleine Literaten-, Maler- und Schauspielerbühne. Leitung: Kay Lorentz.

Wir müssen dran glauben

Ensemble: Jutta Hahn, Hugo Egon Balder, Harald Schmidt.
Musik: Holger Clausen, Ulrich Jokiel, Arthur Lauber. Bass: Thomas Giesler. Drums: Peter Baumgärtner. Piano: Matthias Bröde.
Bühne: Pit Fischer. Regie: Kay Lorentz.

Texte: Wolfgang Franke, Michail Krausnick, Harald Schmidt und andere.

We Must Meet Our Fate ı Uwe Loesch. The text for this concert poster is in black, while the main illustration is in yellow. The juxtaposition of these two colors creates a design divided into very different parts, each performing its own visual function.

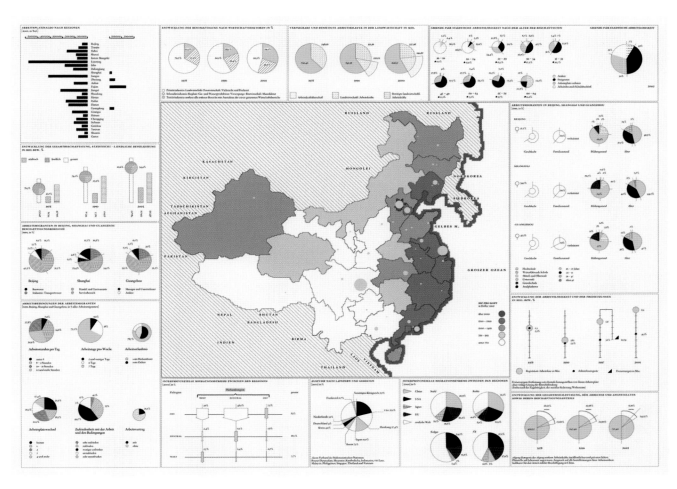

Globalize Me! ı Jung und Wenig. By shading in the relevant portions of these statistic charts in yellow, the reader is led to take in the important information in a single glance and overlook everything that is redundant. The use of softer shades of black makes it possible to differentiate between the various regions on the map.

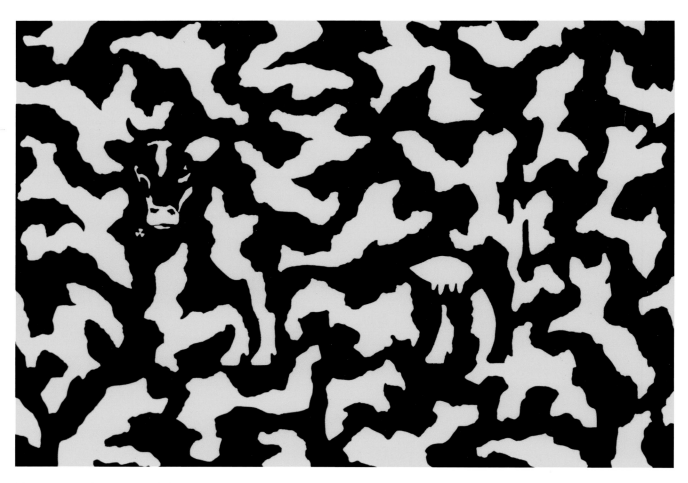

IQ ı Uwe Loesch. A series of black stains on a yellow background serves as a visual metaphor for the radioactivity released in Chernobyl. The viewer mentally fills in the gaps in the outline of the main figure to see a cow. In all actuality, however, the cow is an illusion; it is nothing more than a visual abstraction.

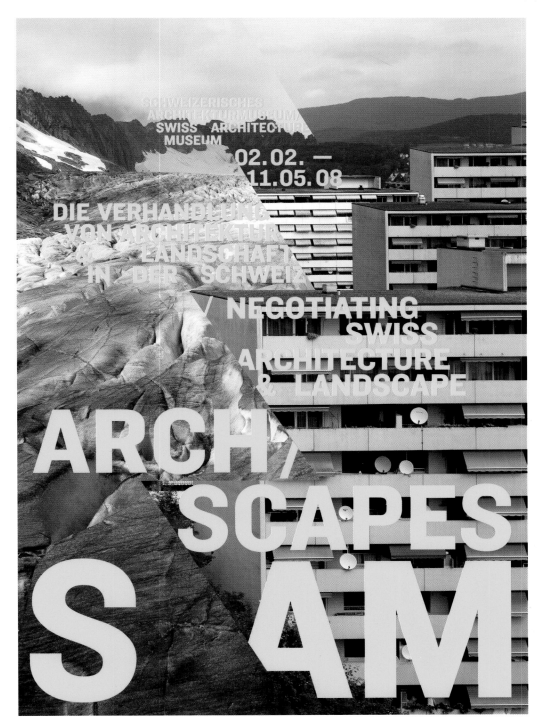

Archscapes ı Claudiabasel. By placing the texts in yellow over a black-and-white photo, this poster acquires a sense of depth, strengthened by the fact that the texts increase in size as they draw "closer" to the viewer, in accordance with the perspective of the image.

PANTONE 809 U

⊾ Registratur:

MARTYN
• Bassbin/play:musik/Red Zone — Rotterdam

TOBESTAR
• Southern Sessions Recordings — Munich

DJ RYAN
• Southern Sessions Recordings — Frankfurt/M.

MC SHOOTA
• Shadybrain Records — Munich

⊾ Sekretariat:

JULIUS KAMMERL
• Compost Records — Munich

MICHAEL REINBOTH
• Compost Records — Munich

⊾ Montag:

25.12.2006
• Start: 23h

DIE REGISTRATUR
• Blumenstraße 28, 80331 Munich

⊾ Info:

»Selekta!« brings you again all facets of Electronic Dance Music to make you sweat, go crazy and feel sexy. We spread peace, love and harmony with soccer-hooligan Martyn: the rising superstar from The Netherlands presenting a special 3 hours wildstyle set spanning from Electro to Minimal to Drum and Bass. South's finest Tobestar & Dj Ryan providing the best of soulful Drum and Bass. Munich legend Michael Reinboth with support from Julius Kammerl catering funky house and oldschool vibes. The evening is under the kinky patronage of MC Shoota. Get your ticket to the journey from Detroit to Chicago to London to Munich and dance different!

Click: www.myspace.com/dancedifferent, www.dieregistratur.de, www.bassbin.com, www.compost-records.com, www.tobestar.com, www.shadybrain.net and www.southernsessions.com

Artwork: www.thepurplehaze.net

® DIE REGISTRATUR
Blumenstraße 28 | 80331 München | www.dieregistratur.de

dance different. I♥DB ⊘ BASSBIN ▯

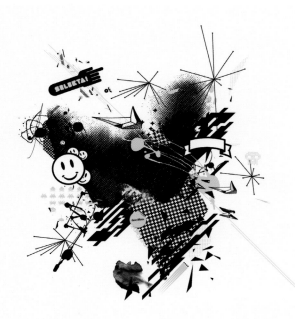

Selekta! ı C100 Purple Haze. The different shades of yellow are in strong contrast to the black and white backgrounds. This is a great color combination for designs that need to dress up the textual information without making it difficult to read.

PANTONE BLACK 6 U

Net Agenda 08 ı Blok. Yellow is the unifying element in this diary designed by Blok. Yellow is the color of the background on several pages, as well as the color used to mark the Sundays. The use of a single typeface enhances the minimalist style of the diary.

PANTONE 809 U

PANTONE BLACK U

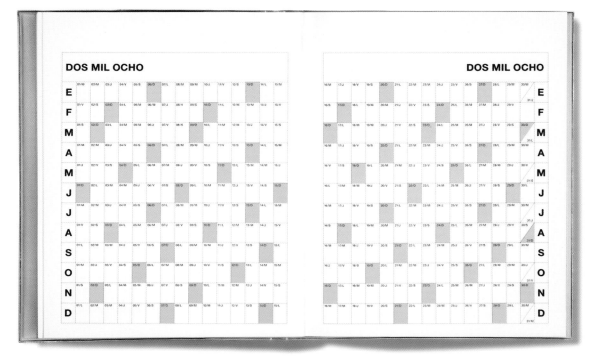

PANTONE 3955 C

PANTONE BLACK C

Deutsche Akademie
für Sprache und Dichtung
Herbsttagung 2005
03.11. – 05.11. in Darmstadt

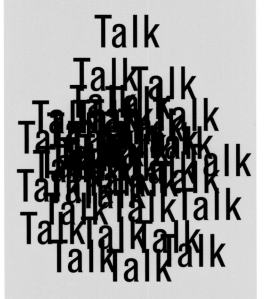

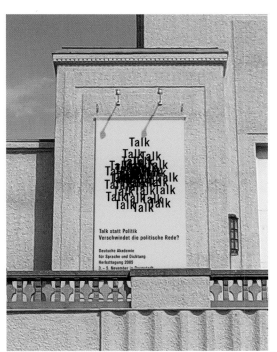

Talk statt Politik

**Verschwindet die
politische Rede?**

Talk statt Politik ı Rosagelb . To symbolize the concept of "stalling"
applied to political discourse, Rosagelb resorted to a black font
on a bright yellow background, and the word "talk" overlaid and
repeated several times, a visual metaphor for mindless chatter.

PANTONE YELLOW C

PANTONE BLACK C

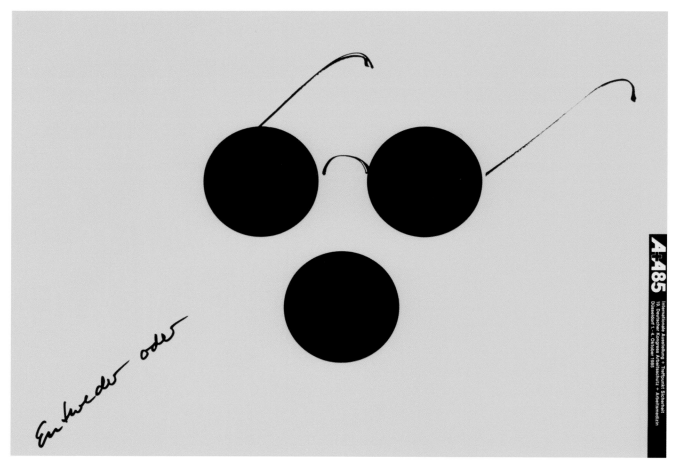

Either or … ı Uwe Loesch. The color combination of black and yellow is closely associated with warning signs. Hence, three black dots on a yellow background are all Uwe Loesch needs to give the idea of a human face in this poster for the A+A Fair on safety and protection at work.

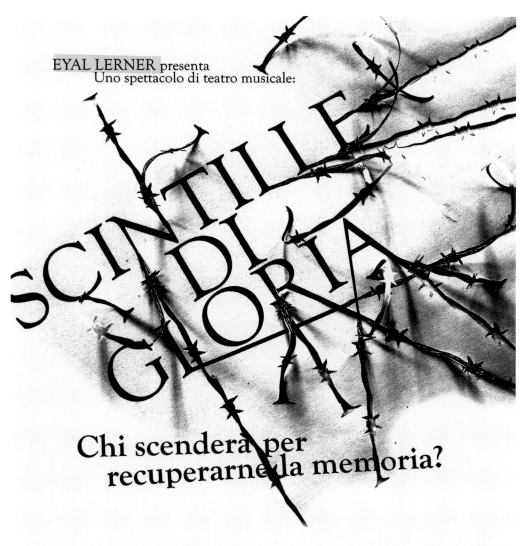

EYAL LERNER presenta
Uno spettacolo di teatro musicale:

SCINTILLE
DI
GLORIA

Chi scendera per
recuperarne la memoria?

Cura dell'allestimento Eyal Lerner

Musiche di Weill, Stravinskij, Ullman, Zosi, Pärt, Schoenfield

Testi Dalfino, Brecht, Ramuz, Kien, Prager

Interpreti Eyal Lerner (narrazione, canto), Laura Dalfino (soprano)
Marco Ortolani (clarinetto), Alberto Bologni (violino),
Andrea Noferini (violoncello), Giuseppe Bruno (pianoforte)

Scintille di Gloria ı Oded Ezer. This poster was designed to
promote a play. The yellow highlights the names of the actors,
director, and playwrights, making them look as if they had been
underlined with a fluorescent marker, just as one would highlight
lines of text in a script.

PANTONE YELLOW C

Ritter Zamet ı Jung und Wenig. Color, as in the case of this poster promoting an art exhibition, may be just another element in deconstructed designs. On the one hand, color pictures add confusion to the whole while, on the other, they serve to unify the design.

PANTONE BLACK C

Ellery Eskelin Trio ı Niklaus Troxler. Poster for a jazz concert. The designer used a font created from circles and straight lines that represent the various parts of a saxophone. The design sacrifices legibility to enhance the poster's immediate visual impact.

PANTONE YELLOW C

PANTONE 1505 C

Marc Ribot ı Niklaus Troxler. Poster for a jazz concert, featuring guitarist Marc Ribot. The surface of the design is completely covered with vertical lines, metaphorically representing the strings of a guitar.

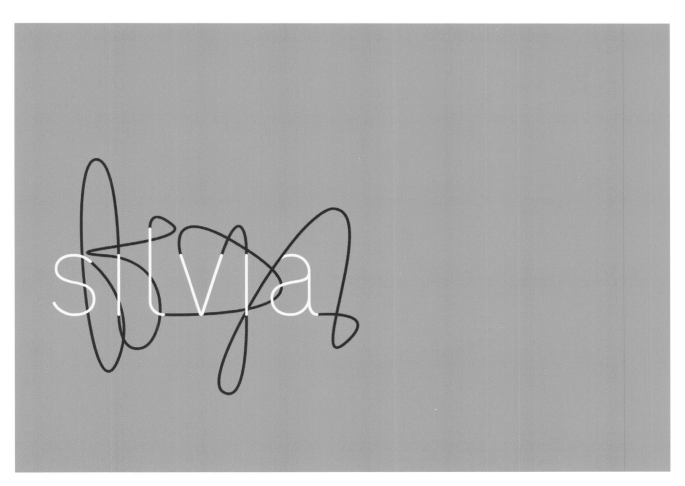

Silvia ı Christof Nardin. In this work, which consists of the graphic image and logo for the hairdressing salon Silvia, the minimalist concept has been applied both in terms of color and distribution of space and typography. The negative image of the lettering shows up against the white of the paper on which it is written.

PANTONE ORANGE 021 C

PANTONE BLACK C

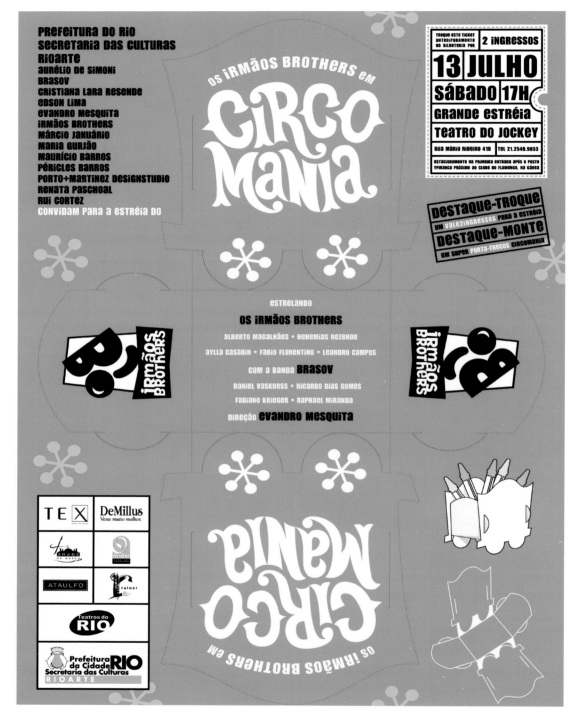

Circomania **ı** Porto+Martinez designStudio. This invitation, inspired by old traveling circus wagons, uses a font exclusive to the Irmãos Brothers, designed by Porto+Martinez. The invitation is a perforated sheet of A4 paper, which can easily be assembled to make a wagon.

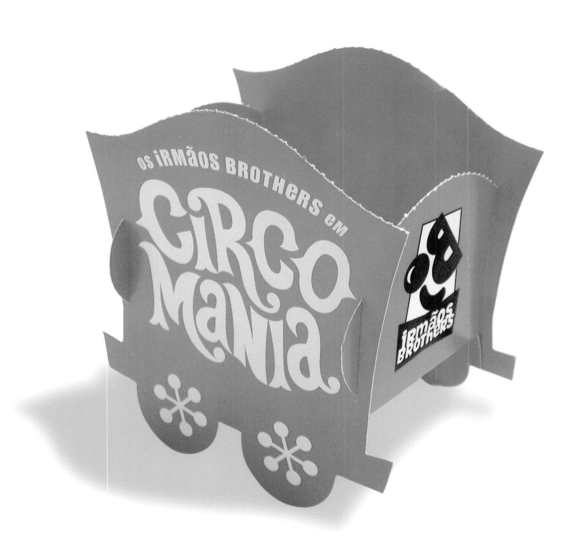

PANTONE 137 C

PANTONE 424 C

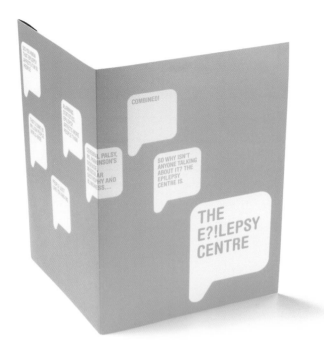

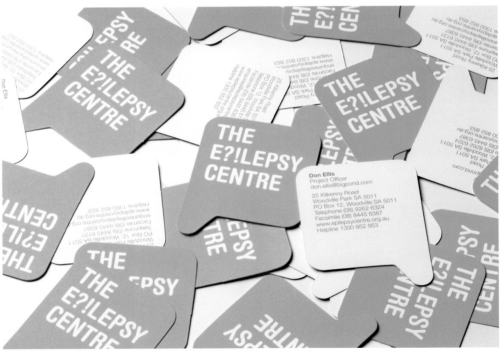

Epilepsy Centre ı Parallax. This identity for an information center offering advice on epilepsy is used to facilitate dialog between the patients, the general public, and the government. The design is intended to provide information on the activities of the organization rather than dwelling on the effects of the disease.

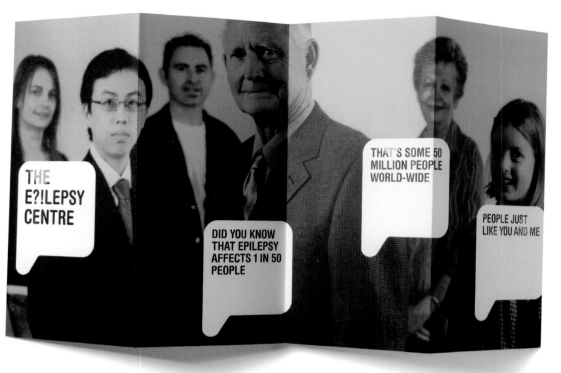

Shiner CD cover ı OhioGirl Design (Andy Mueller). This design for the band Shiner is based on two elements: the color orange and the silhouettes of the members of the band in black. A white oval (alluding to the "egg" in the title) at the bottom of the cover lends balance to the design so that it is not all left "hanging" at the top.

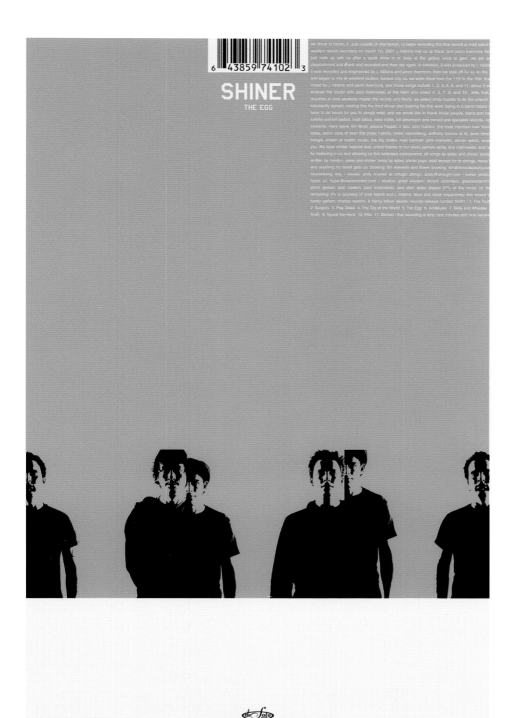

PANTONE 151 C

PANTONE BLACK C

PANTONE 151 C

PANTONE 2735 C

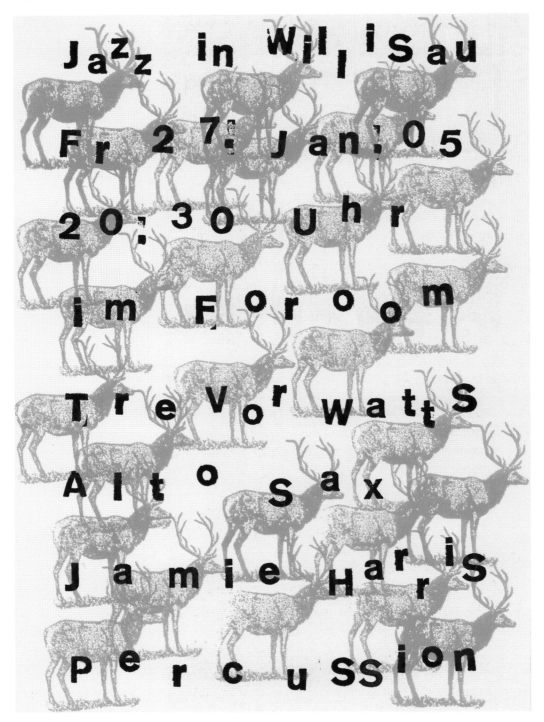

Trevor Watts-Jamie Harris ı Niklaus Troxler. The use of typography, along with the graphic motifs in the background, printed in two different colors, conveys a wintry atmosphere while at the same time endows this poster design with a touch of surrealism.

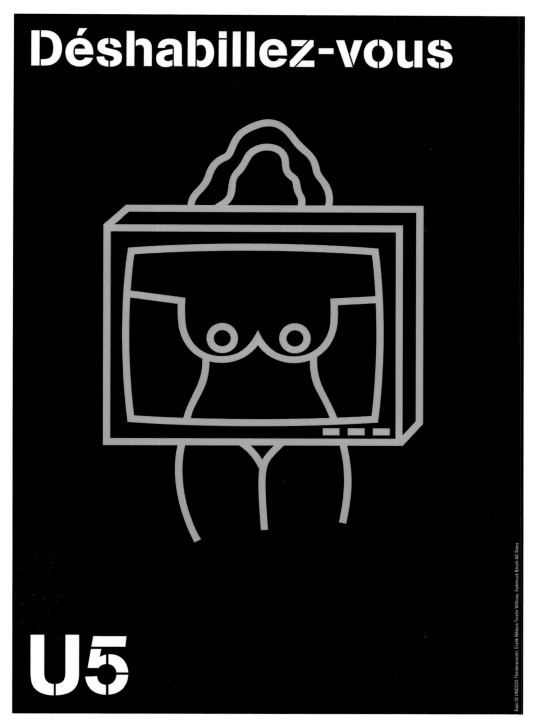

U5 Déshabillez-vous ı Niklaus Troxler. Poster for a play performed for UNESCO and staged at the Swiss National Exhibition in 2002. The work deals with exhibitionism on contemporary television. The use of a warm color on a black background alludes to the concept of "sex."

PANTONE 151 C

PANTONE BLACK C

Conundrums poster ı Pentagram (Harry Pearce). Divided into squares that match the folds in the poster, this typographic puzzle resorts to deconstruction and a simple rule: a box, two colors and a typographic font. The orange details add a touch of energy.

Domaine Zumbaum-Tomasi

VINICOLE ÉCOLOGIQUE	*ÖKOLOGISCHER WEINBAU*
83, rue des Aires 34270 Claret ✦ France	Monbijouplatz 12 10178 Berlin ✦ Deutschland
T +33 (0)467 55 78 77 F +33 (0)467 02 82 84	T +49 (0)30 28 39 01 -33 ✦ F -87 M +49 (0)176 240 795 15
www.vin-zumbaum-tomasi.eu	domainezt@vin-zumbaum-tomasi.eu

Zumbaum-Tomasi ɪ BANK™. The folding card for this wine merchant plays with the idea of negatives to offer two versions of the same thing. The over-ornate logo and the colors chosen represent a visual symbol of the company's product: organic wine.

PANTONE 155 U

Marchand de vin

VINICOLE ÉCOLOGIQUE

Guilhem Zumbaum-Tomasi

Distribution en Allemagne
Vertrieb in Deutschland

ÖKOLOGISCHER WEINBAU

Monbijouplatz 12
10178 Berlin ◆ Deutschland

T +49 (0)30 28 39 01 -33 ◆ F -87
M +49 (0)176 240 795 15

commercial@vin-zumbaum-tomasi.eu

PANTONE 476 U

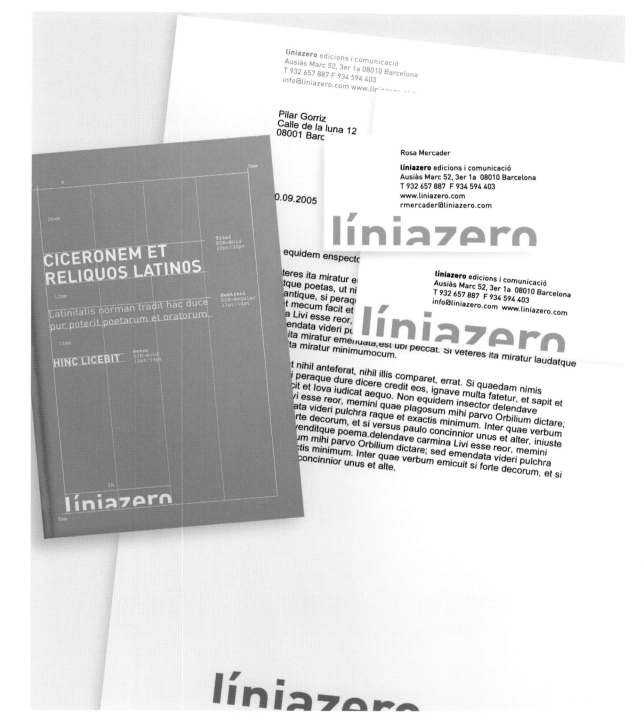

líniazero edicions i comunicació
Ausiàs Marc 52, 3er 1a 08010 Barcelona
T 932 657 887 F 934 594 403
info@liniazero.com www.li...

Pilar Gorriz
Calle de la luna 12
08001 Barc...

Rosa Mercader

líniazero edicions i comunicació
Ausiàs Marc 52, 3er 1a 08010 Barcelona
T 932 657 887 F 934 594 403
www.liniazero.com
rmercader@liniazero.com

0.09.2005

líniazero

líniazero edicions i comunicació
Ausiàs Marc 52, 3er 1a 08010 Barcelona
T 932 657 887 F 934 594 403
info@liniazero.com www.liniazero.com

líniazero

equidem enspecto

...eteres ita miratur e...
...tque poetas, ut ni...
...antique, si peraq...
...et mecum facit et...
...a Livi esse reor,
...endata videri pu...
...ita miratur emendata, est ubi peccat. Si veteres ita miratur laudatque
...ita miratur minimumocum.

...et nihil anteferat, nihil illis comparet, errat. Si quaedam nimis
...i peraque dure dicere credit eos, ignave multa fatetur, et sapit et
...cit et Iova iudicat aequo. Non equidem insector delendave
...vi esse reor, memini quae plagosum mihi parvo Orbilium dictare;
...ata videri pulchra raque et exactis minimum. Inter quae verbum
...rte decorum, et si versus paulo concinnior unus et alter, iniuste
...venditque poema.delendave carmina Livi esse reor, memini
...um mihi parvo Orbilium dictare; sed emendata videri pulchra
...ctis minimum. Inter quae verbum emicuit si forte decorum, et si
...concinnior unus et alte.

CICERONEM ET
RELIQUOS LATINOS

Latinitatis norman tradit hac duce
pur poterit poetarum et oratorum

HINC LICEBIT

líniazero

líniazero

Líniazero ı Pilar Gorriz. For the design of the stationery items for
the Líniazero publishing and communications agency, maximum
simplicity was sought in arranging the items. Hence the use of
black along with the corporate 158 U color scheme.

PANTONE 158 C

PANTONE BLACK C

Lion Feuchtwanger
Jud Süss

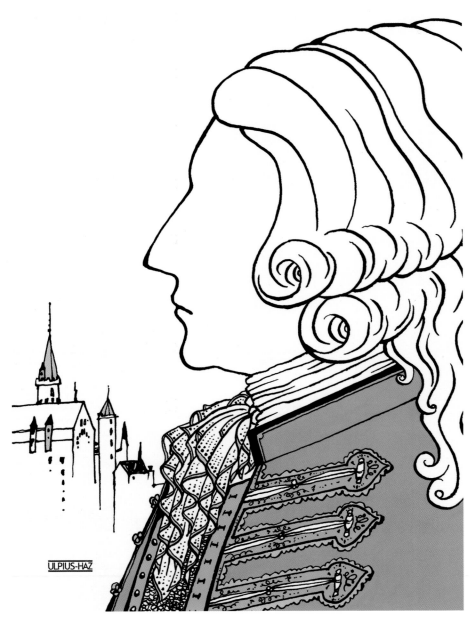

ULPIUS-HÀZ

Jud Süss (Jew Süss) ɪ Design and art direction by Clare Skeats, illustrated by Kazuko Nomoto. In this cover, produced by the Hungarian publisher Ulpius-Hàz, two colors have been used, along with a neutral typeface, to create a minimalist appearance linking up the various items of editorial content.

PANTONE 172 U

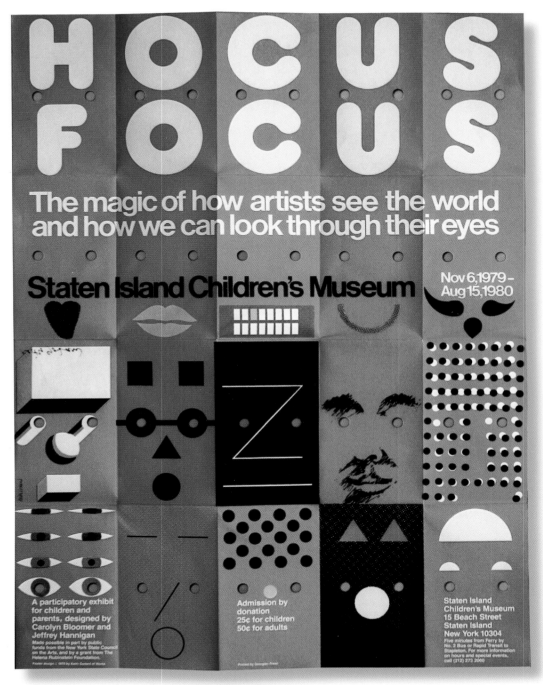

Hocus Focus ı StudioWorks (Keith Godard). This is a low-budget poster created using traditional printing techniques. Instead of perforation, each poster has been folded over and stacked one on top of the other. Two holes are then made by drilling through the whole pile.

PANTONE BLACK U

PANTONE 804 C

PANTONE BLACK C

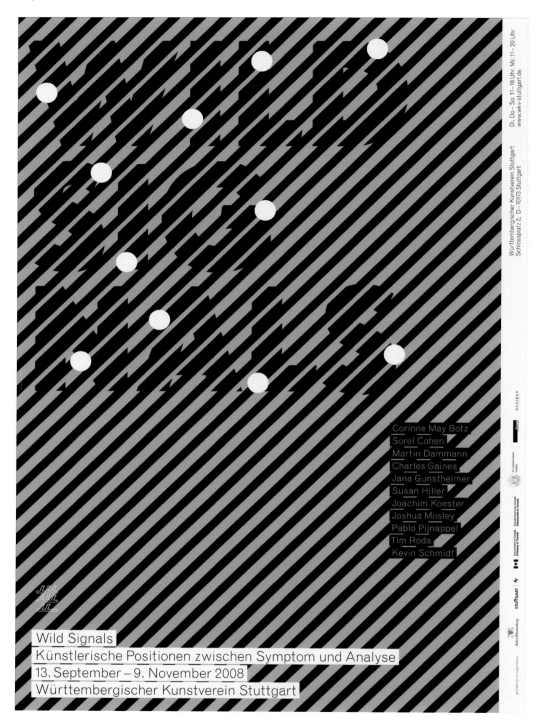

Di, Do – So 11–18 Uhr, Mi: 11 – 20 Uhr
www.wkv-stuttgart.de

Württembergischer Kunstverein Stuttgart
Schlossplatz 2, D – 70173 Stuttgart

Corinne May Botz
Sorel Cohen
Martin Dammann
Charles Gaines
Jana Gunstheimer
Susan Hiller
Joachim Koester
Joshua Mosley
Pablo Pijnappel
Tim Roda
Kevin Schmidt

Wild Signals
Künstlerische Positionen zwischen Symptom und Analyse
13. September – 9. November 2008
Württembergischer Kunstverein Stuttgart

Wild Signals ı L2M3 Kommunikationdesign (Sascha Lobe,
Dirk Wachowiak). This poster announces the Wild Signals
exhibition, which features approximately 100 different pieces
by international artists who use scientific methodology in their
creations. The bands in the design are reminiscent of tiger stripes,
and allude to the "wild" concept expressed in the title.

KONZERTE, DJS, PERFORMANCES:
DJ Q-BERT (USA) PLAID (GB) FENNESZ
AND LILLEVAN (A/SE) VICKY BENNETT/PEO-
PLE LIKE US (GB) JUNCTION SM AKA SONJA
MOONEAR AND DANDY JACK (CH) LARYTTA (CH) YAN
DUYVENDAK (CH) PHILLIP JECK (GB) BIRDY NAM NAM (F)
THE GOLDFINGER BROTHERS (CH) STROTTER INST./FLO
KAUFMANN (CH) FRÉDÉRIC POST (CH) 8GG (CN) HUZI (CN) VISUALS: VJ
LABEL VIDEOKULTUR (CH) KOPFHÖRER-KONZERTE PRÄSENTIERT VON:
INTERDISCO (CH): SONIC BLOOM, B°TONG, THE INTERDISCO LIVESQUAD UND EVEREST
RECORDS (CH): [SIC], LES POISSONS AUTISTES, HOPEN, MONPETITPONEY, EVEREST

THEMA 2008
AUFZEICHNEN –
SPEICHERN –
VERARBEITEN

Record, Record

— SHIFT IN PROGRESS: MIT STUDIE-
RENDEN VON SCHWEIZER KUNST-
HOCHSCHULEN (FHNW MEDIENKUNST,
FHNW KUNST, ZHDK MEDIALE KÜNS-
TE, F&F, HKB MUSIK- UND MEDIEN-
KUNST, HSLU VIDEODEPARTMENT)

ELECTRONIC
ARTS

SHIFT
FESTIVAL

WWW.
SHIFTFESTIVAL.
CH

23.

DER
ELEKTRONISCHEN
KÜNSTE

26.10.

SHIFT 2008 UMFASST LIVE-
KONZERTE, AUSSTELLUNG-
EN, FILME UND VIDEOS, EINE
KONFERENZ, PROJEKTE VON
MUSIK- UND KUNSTHOCH-
SCHULEN, KÜNSTLERGESPRÄCHE, EIN
KINDERPROGRAMM UND PARTYS.

— AUSSTELLUNG: MARTIN BRAND (D)
GARRETT DAVIS/KIERAN GILLEN (USA)
ALEKSANDRA DOMANOVIĆ (SLO/D) ALEJO
DUQUE/LORENZ SCHORI (CO/CH) ETOY.COR-
PORATION (CH) VERENA FRIEDRICH (D)
MAIA GUSBERTI/NIK THÖNEN (CH/A) ESTHER
HUNZIKER (CH) FLO KAUFMANN (CH) OLIVER
LARIC (A/D) KRISTIN LUCAS (USA) CHRISTIAN
MARCLAY (USA) AGNES MEYER-BRANDIS (D) FRÉDÉRIC POST (CH) LUCIEN SAMAHA (USA)
MICHAEL S. RIEDEL (D) LAURENT SCHMID (CH/CH) DAVID TROY (USA) VALENTINA VUKSIC (CH/NL)
— FILME + VIDEOS VON SADIE BENNING (USA) KEREN CYTTER (ISR) KARL KELS (D) OLIVER
LARIC (A/D) JONAS MEKAS (USA) SETH PRICE (USA) ANRI SALA (ALB/F) SEAN
SNYDER (USA) EMILY WARDILL (UK) ANDRO WEKUA (CH) u.a. — KINDER-
PROGRAMM MIT ELEKTRONISCHEN SPIEL-INSTRUMENTEN
VON MICHAEL BRADKE (D) — KÜNSTLERGESPRÄCHE
— KONFERENZ ‹KULTURSPEICHER. AUFSCHREIBE-
SYSTEME IM ZEITALTER DIGITALER ARCHIVE.›
IN ZUSAMMENARBEIT MIT DEM INSTITUT
FÜR MEDIENWISSENSCHAFTEN DER
UNI BASEL — RESTAURANT —

BASEL

DREISPITZ
MÜNCHEN-
STEIN

08

merian stiftung basel | Lotteriefonds Basel-Stadt | kulturelles.bl | [logos]
MIGROS kulturprozent | reinhardt | [logo] | UWB | auviso
ERNST GÖHNER STIFTUNG 2020 | Alfred Richterich Stiftung | GRAFIK: JIRI OPLATEK (CLAUDIABASEL)
DRUCK: AHN DIEDRUCK

Shift Electronic Arts Festival ⅰ Claudiabasel. The subtle palette
of colors offsets the excessive amount of information. Saturating
a design like this one with bright colors would only make it
difficult to read. Sans serif fonts are traditionally associated with
electronic music.

Gerrit Rietveld Academy **ı** Ingeborg Scheffers, Marriëlle Frederiks (Gulden Bodem). By playing with bands of two colors and different thicknesses, it is possible to achieve an effect that is similar to the one created using 3-D images. The result is slightly psychedelic, since more shades of color seem to be generated than have in actual fact been used in the design.

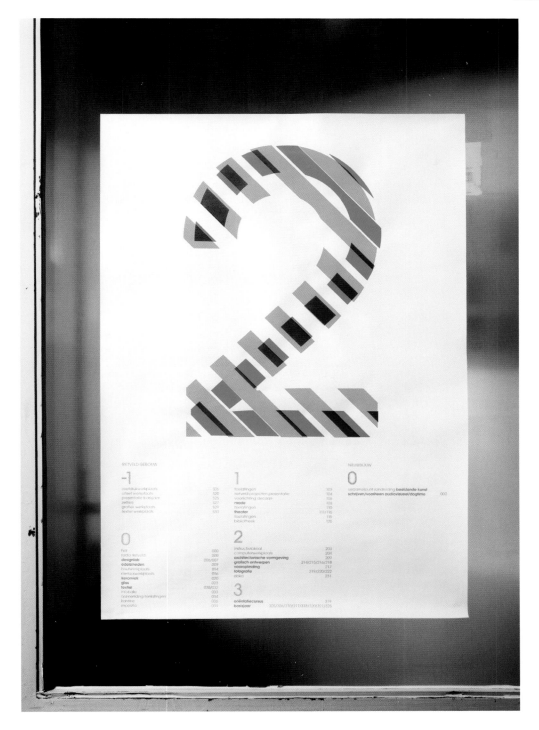

PANTONE 1375 C

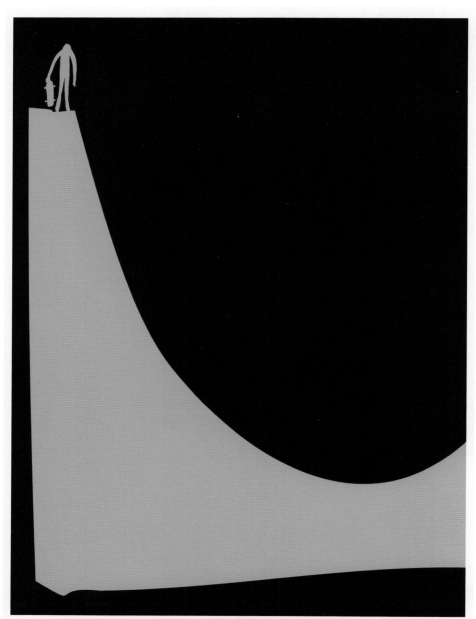

PANTONE 260 C

Pedro Sideways | OhioGirl Design (Andy Mueller). In this poster announcing the creation of a charity mural to save a skate-park, color is used to guide and direct the viewer in the appropriate direction. The reader, along with the figure at the top of the poster, slides down the orange ramp toward the bottom of the illustration.

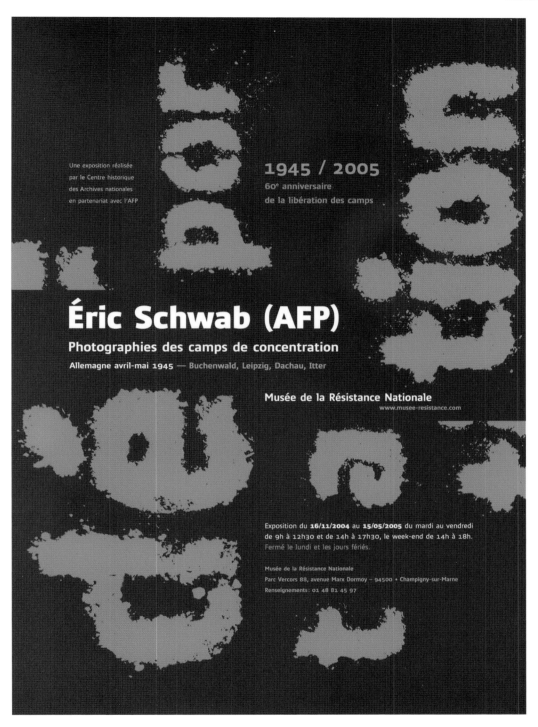

Une exposition réalisée
par le Centre historique
des Archives nationales
en partenariat avec l'AFP

1945 / 2005
60ᵉ anniversaire
de la libération des camps

Éric Schwab (AFP)

Photographies des camps de concentration

Allemagne avril-mai 1945 — Buchenwald, Leipzig, Dachau, Itter

Musée de la Résistance Nationale
www.musee-resistance.com

Exposition du **16/11/2004** au **15/05/2005** du mardi au vendredi
de 9h à 12h30 et de 14h à 17h30, le week-end de 14h à 18h.
Fermé le lundi et les jours fériés.

Musée de la Résistance Nationale
Parc Vercors 88, avenue Marx Dormoy – 94500 • Champigny-sur-Marne
Renseignements : 01 48 81 45 97

Historical exhibition poster ı Olivier Umecker. Poster for a photo
exhibition on the Holocaust. Due to the impossibility of using
photographs from the exhibition, it was decided to opt for a purely
typographic design based on the Ubik font, designed by Thierry
Puyfoulhoux.

PANTONE 1525 C

PANTONE 7546 C

PANTONE 1635 C

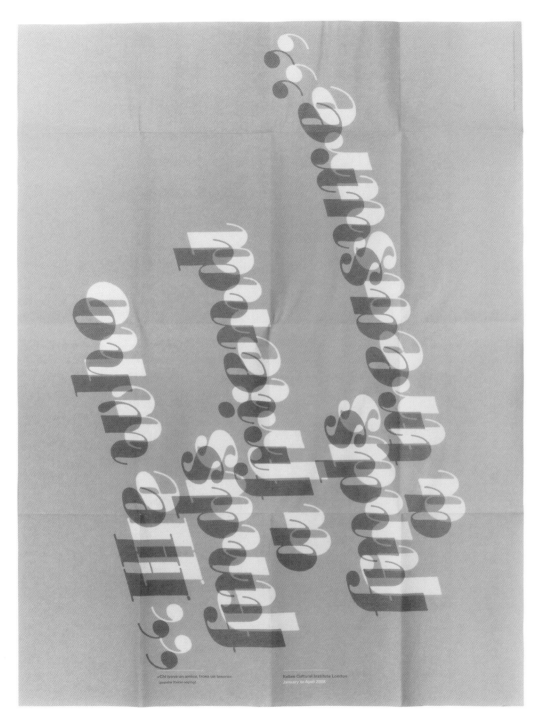

Italian Cultural Institute London ı Brighten the Corners, Ian Gabb.
This two-color poster for the program of events at the Italian
Cultural Institute in London displays the phrases most often used
by the teaching staff and functions as the cover enclosing each of
the center's programs.

PANTONE 304 C

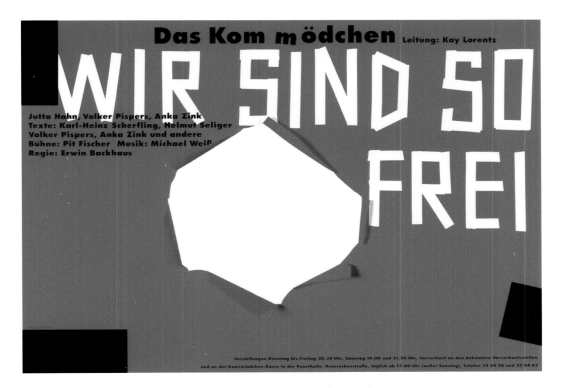

We Are So Easy ı Uwe Loesch . To ensure a balanced use of several different typefaces in a single design, one of the most popular solutions is to dispense with the idea of using color and opt for a basic combination such as the following: red, black, and white.

PANTONE RED 032 C

PANTONE BLACK C

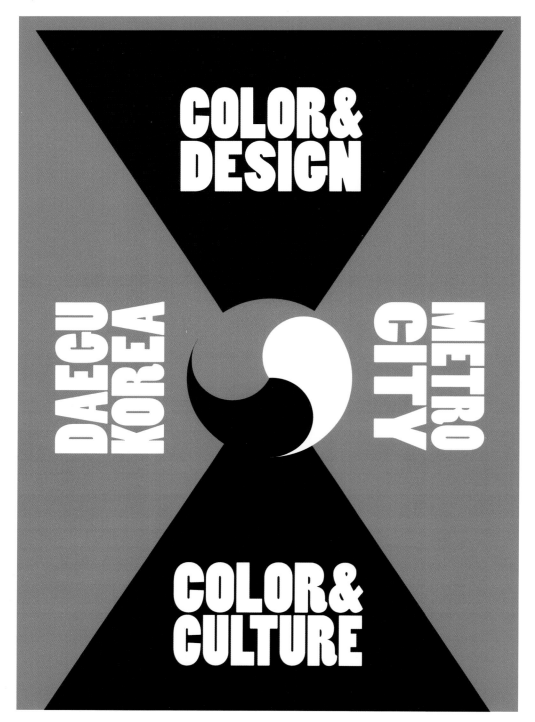

Daegu Cosmopolitan City 2007 ı Richard B. Doubleday. This simple poster, divided into four parts joined together by a circle evoking the yin-yang symbol, was designed to announce the Color & Culture and Color & City theme at the Daegu International Poster Exhibition (South Korea).

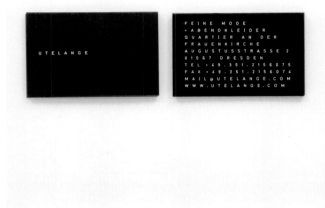

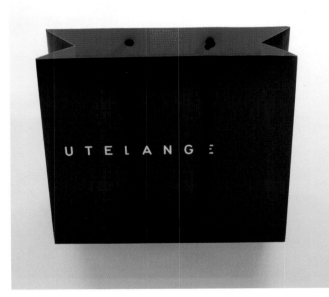

Ute Lange ı Amen. For her design using stationery and promotional items, Ute Lange has resorted to one of the combinations *par excellence* for elegant colors: red and black, two colors that are usually associated with the luxury and exclusive nature of evening dresses.

PANTONE RED 032 C

PANTONE BLACK C

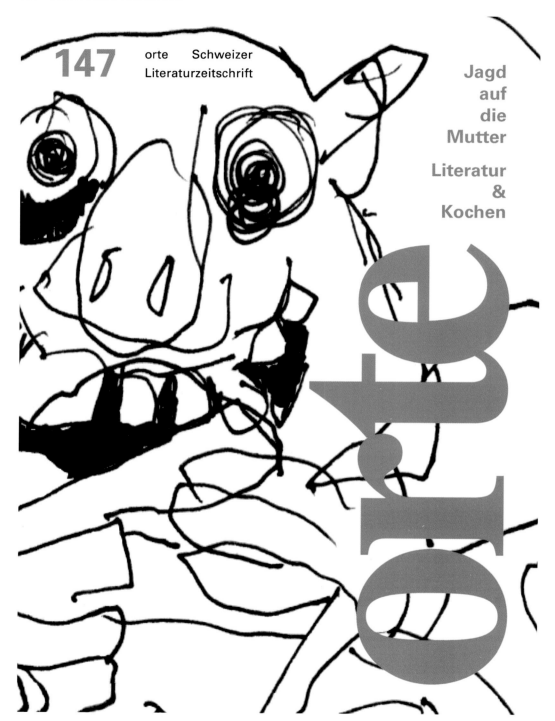

147 orte Schweizer
Literaturzeitschrift

**Jagd
auf
die
Mutter**

**Literatur
&
Kochen**

Orte

Orte Magazin Nr. 147 ı Designalltag Zürich (Ruedi Rüegg). Two-color cover for the compact format literary magazine *Orte*. The Univers Bold font has been applied over the black illustration created by Sonija Studer for the book *Zart und Deftig* by Peter Brunner.

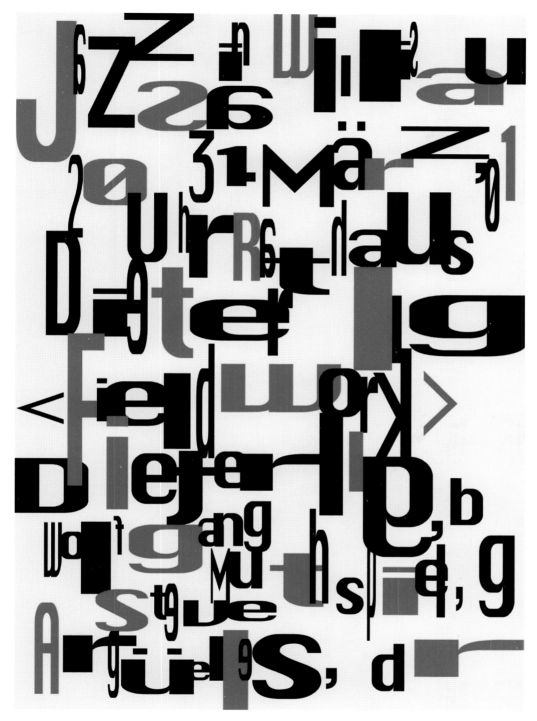

Dietr Illg & Fieldwork ı Niklaus Troxler. The movement suggested by jazz music can be perceived in this concert poster by the way the letters lengthen and rotate to give event information. The colors red and black were chosen because of their strong contrast.

PANTONE RED 032 C

PANTONE BLACK C

PANTONE RED 032 C

PANTONE BLACK C

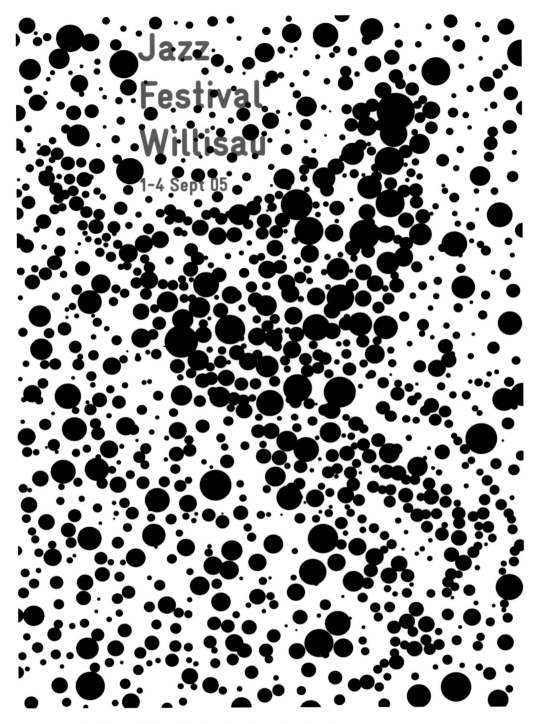

Jazz
Festival
Willisau
1–4 Sept 05

Jazz Festival Willisau ı Niklaus Troxler. For this poster for a jazz concert, the designer used hundreds of different-sized black dots to represent various images associated with this type of music—in this case, a human figure with a musical instrument.

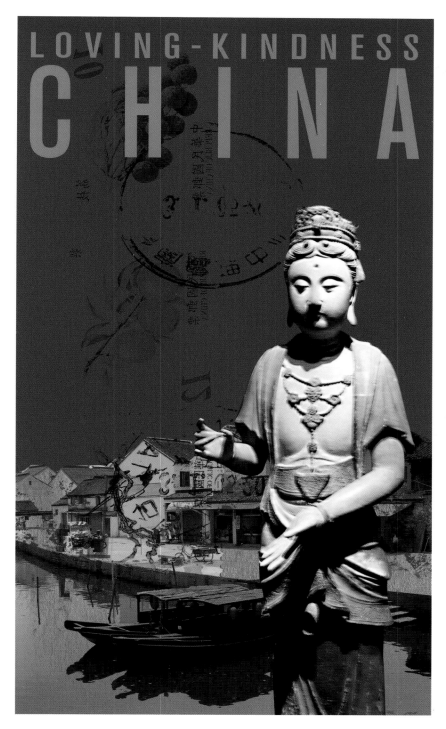

Loving-Kindness China 2008 ı Richard B. Doubleday. Designed for the New Graphic and Design College of Nanjing Arts Institute in Nanjing (China), this poster announces the exhibition commemorating the earthquake in Sichuan on May 12, 2008, that killed more than 65,000 people.

PANTONE RED 032 C

PANTONE BLACK C

PANTONE RED 032 C

PANTONE 300 C

Albin Brun-Bruno Amstad ı Niklaus Troxler. Poster for a jazz
concert given by two musicians. The poster was designed using
bands of two colors and different thicknesses, symbolizing the
interaction between the two musicians in a common space,
namely the stage.

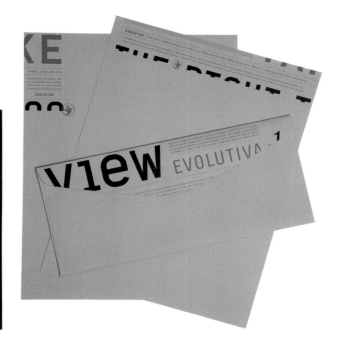

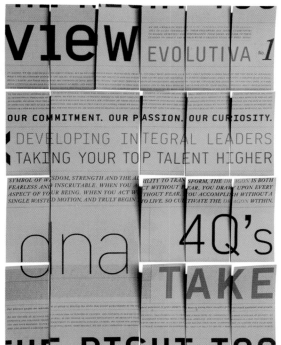

Evolutiva ı Blok. Evolutiva is a company that specializes in leadership training. The promotional materials reflect the leadership process and the values it represents, with the fonts used being a way to reach and engage the reader.

PANTONE RED 032 U

PANTONE BLACK U

PANTONE 180 U

PANTONE BLACK C

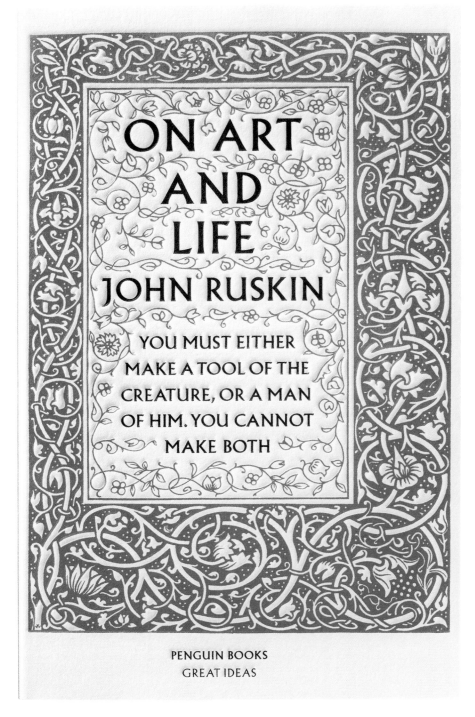

Great Ideas Series ׀ David Pearson. Typography is used in this design to place each of the one hundred books making up this series in their historical and geographical context by means of a limited palette of colors. The typeface in counter-relief on off-white matte paper simulates the traditional method of printing.

PANTONE 180 U

FRIEDRICH NIETZSCHE
WHY I AM SO WISE

I know my fate. One day there will be associated with my name the recollection of something frightful—of a crisis like no other before on earth, of the profoundest collision of conscience.

Penguin Books　　**Great Ideas**

PANTONE BLACK C

PANTONE 185 C

PANTONE BLACK C

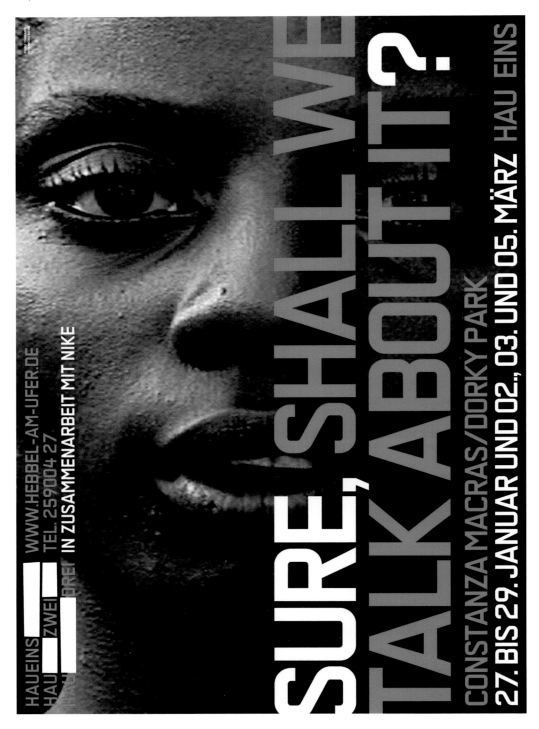

Hau 1 Double Standards. The enormous amount of information that had to be shown in this poster for a theater forced Double Standards to divide it into two symmetrical parts: one for the text and the other for the photograph. The colors chosen refer to the theater logo, in red and black.

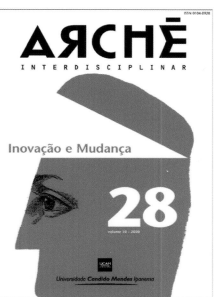

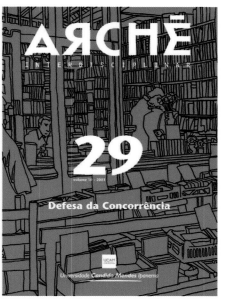

Covers for Arché ı Porto+Martinez designStudio. For these covers for the academic journal *Arché*, the logo was redesigned from a basic two-color palette to cut costs and unify esthetics. The collage work and various graphic experiments are loosely adapted to the topics in the journal.

PANTONE 186 C

PANTONE BLACK C

PANTONE 186 C

PANTONE BLACK C

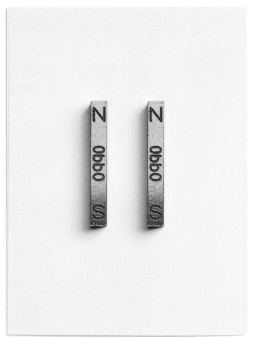

Umanage ı Parallax. "Attraction" is the key concept underlying the branding and promotional printed matter for the Umanage brand, which has organized a series of lectures on how a business can increase its client base. The initial "U" in the brand name symbolizes a magnet.

PANTONE 186 C

PANTONE BLACK C

PANTONE 192 C

PANTONE YELLOW C

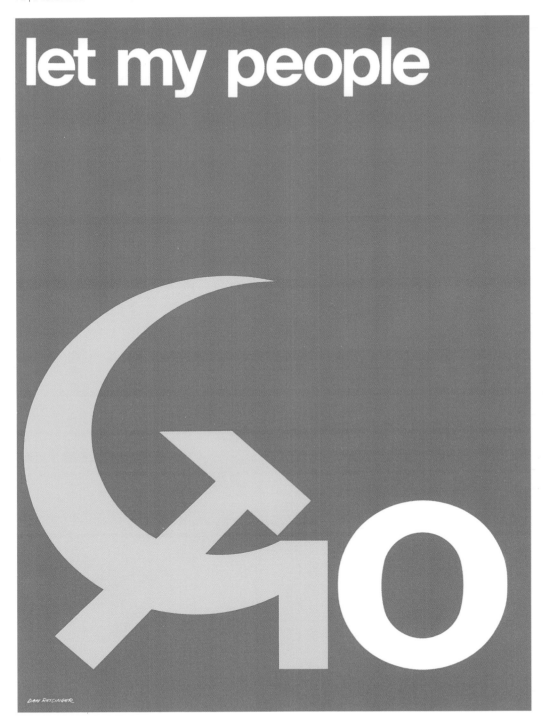

Let My People Go ı Dan Reisinger. This poster, opposing the
Soviet policy of banning Jews from leaving the USSR, includes
the Communist hammer and sickle on a red background, very
obviously playing with the similarity of the sickle and the letter
"G" in the word "Go."

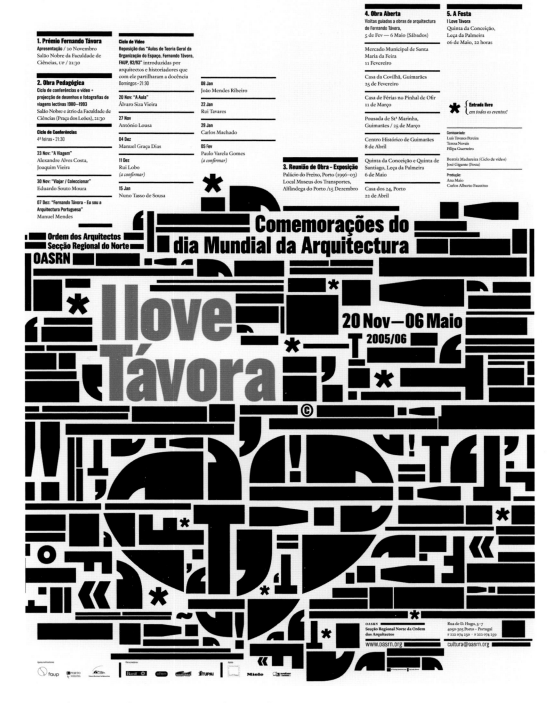

I Love Távora ı R2. This poster pays tribute to the Portuguese architect Fernando Távora and evokes the modernistic and humanistic aspects of his work. The text and combination of images form an organic mass suggestive of urban development, with it being possible to make out the image of a heart amongst the buildings.

PANTONE 485 C

PANTONE BLACK C

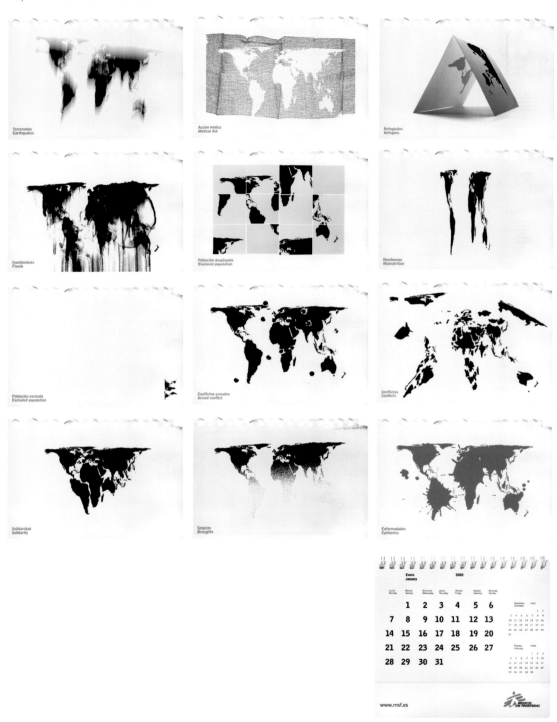

MSF ı Estudio Diego Feijóo. The corporate red of Doctors without Borders is the nexus linking the pages of this calendar, which provides information along with iconic images of various humanitarian crises. The viewer thus immediately associates the color red with the urgency, danger and blood of the victims in those crises.

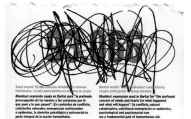

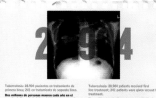
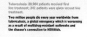
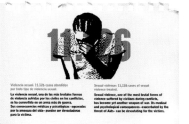

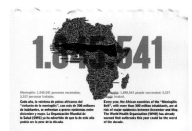
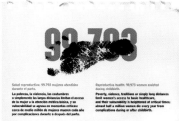
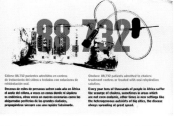

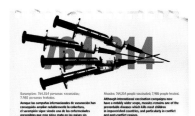
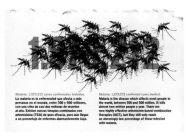

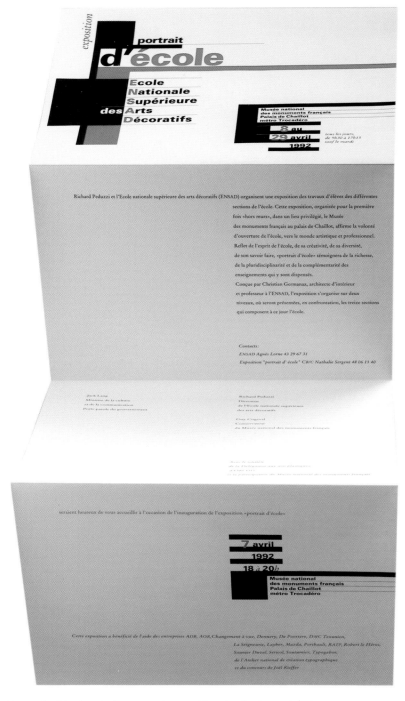

Portrait d'école ı Rudi Meyer. Created for the École Nationale Supérieure des Arts Décoratifs, this project measures 40 × 60 inches. The fonts used in the poster (Univers and Garamond) add sobriety to a design, which, in itself, is sober and minimalist.

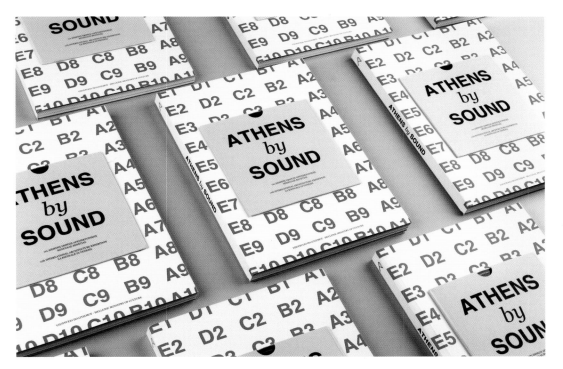

Athens by Sound ι Company. Designed for the Greek pavilion in the eleventh Architecture Biennial in Venice, the winning project is an interactive map of the soundscape of Athens, based on the "listen - don't just look" concept. The use of red attempts to focus the viewer's attention on sounds.

PANTONE 485 C

PANTONE BLACK C

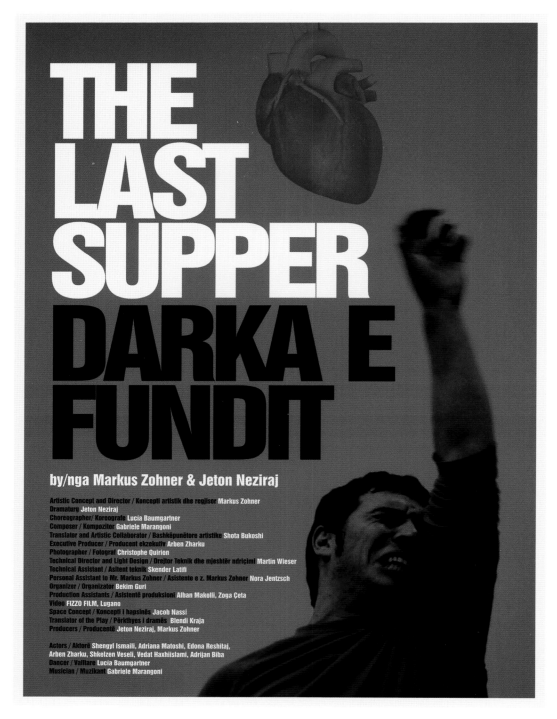

THE LAST SUPPER

DARKA E FUNDIT

by/nga Markus Zohner & Jeton Neziraj

Artistic Concept and Director / Koncepti artistik dhe regjisor Markus Zohner
Dramaturg Jeton Neziraj
Choreographer/ Koreografe Lucia Baumgartner
Composer / Kompozitor Gabriele Marangoni
Translator and Artistic Collaborator / Bashkëpunëtore artistike Shota Bukoshi
Executive Producer / Producent ekzekutiv Arben Zharku
Photographer / Fotograf Christophe Quirion
Technical Director and Light Design / Drejtor Teknik dhe mjeshtër ndriçimi Martin Wieser
Technical Assistant / Asitent teknik Skender Latifi
Personal Assistant to Mr. Markus Zohner / Asistente e z. Markus Zohner Nora Jentzsch
Organizer / Organizator Bekim Guri
Production Assistants / Asistentë produksioni Alban Makolli, Zoga Ceta
Video FIZZO FILM, Lugano
Space Concept / Koncepti i hapsinës Jacob Nassi
Translator of the Play / Përkthyes i dramës Blendi Kraja
Producers / Producentë Jeton Neziraj, Markus Zohner

Actors / Aktorë Shengyl Ismaili, Adriana Matoshi, Edona Reshitaj,
Arben Zharku, Shkelzen Veseli, Vedat Haxhiislami, Adrijan Biba
Dancer / Valltare Lucia Baumgartner
Musician / Muzikant Gabriele Marangoni

The Last Supper ı projectGRAPHICS. In order to provide a visual representation of the link between the two directors of this play, it was decided to use two colors and two different fonts. The bright red and the photograph of the actor convey the emotive quality of the play's content.

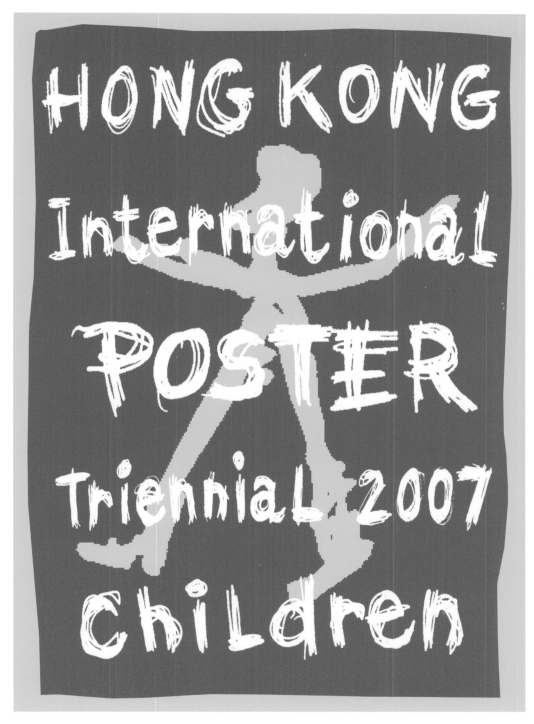

Hong Kong International Poster Triennial 2007 ı Richard B. Doubleday. For this poster for the Hong Kong Triennial, the designers used the colors of the Chinese flag. It is an extremely effective design scheme since it enables basic information to be identified at first glance without the need for further explanation, enabling the viewer to focus on the other items in the message.

PANTONE 1797 C

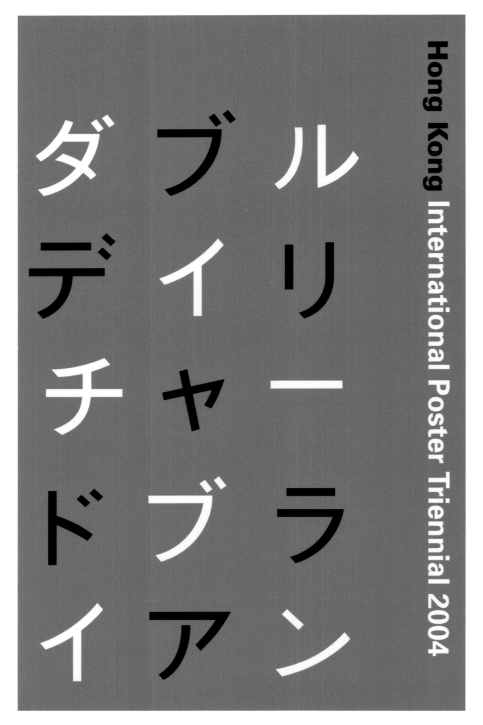

Hong Kong International Poster Triennial 2004

ダデチドイ
ブイャブア
ルリーラン

Hong Kong International Poster Triennial 2004 ı Richard B.
Doubleday. Richard B. Doubleday has used the red in the Chinese
flag, but has ignored the yellow in favor of black, which alternates
with white in Chinese calligraphic icons that function as text but
also work as illustrations.

PANTONE BLACK C

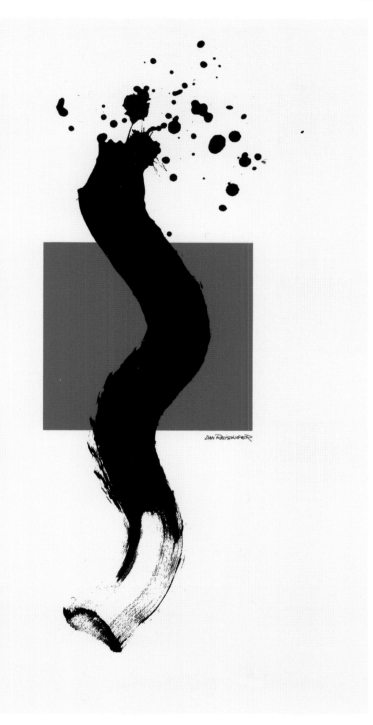

Dan Reisinger Exhibition ı Dan Reisinger. The poster for the exhibition featuring the work of the designer himself shows a *sumi-e* painting and a red square. The typographical items are concentrated on the left, with the text being kept separate from the image. In this way, it is possible to have a copy of the original painting without any text on it.

PANTONE WARM RED C

PANTONE BLACK C

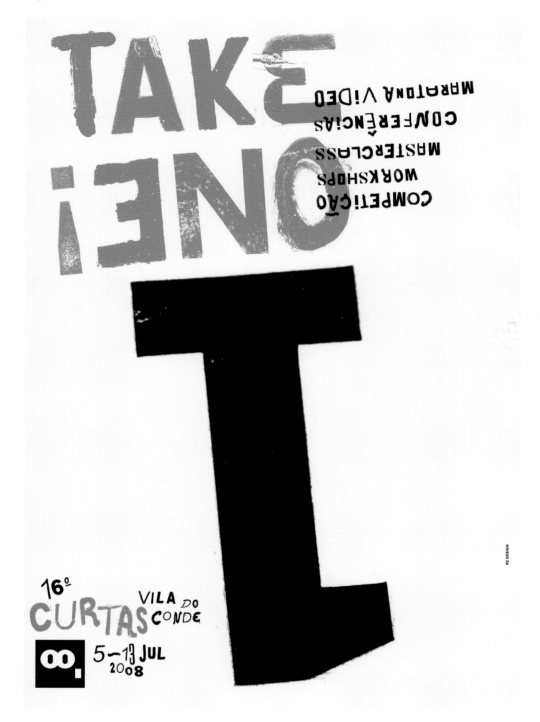

Take One ɪ R2. Curtas is an international short film festival held each year in a small fishing village in Portugal. The original typefaces that can be read on the boats have been used in the poster, together with the Akkurat font, in the manner of a random composition.

Fumalab Records No. 03 ı BANK™. In this series of record covers, only the colors change. Their lack of visual eloquence works well with the concept of the Fumakilla record label. The name of the artist and the title and length of the record are always added in the same way on every cover.

ULPIUS-HÁZ

Giuseppe Tomasi di Lampedusa
A párduc

A párduc (The Leopard) ı Design and art direction by Clare Skeats, illustrated by Kazuko Nomoto. For this series of two-color covers displaying a minimalist style, designed for the Ulpius-Ház publishing house, a font was used that was stylistically neutral. The ink drawing is rich in detail and irregularities, infusing the graphic design with warmth.

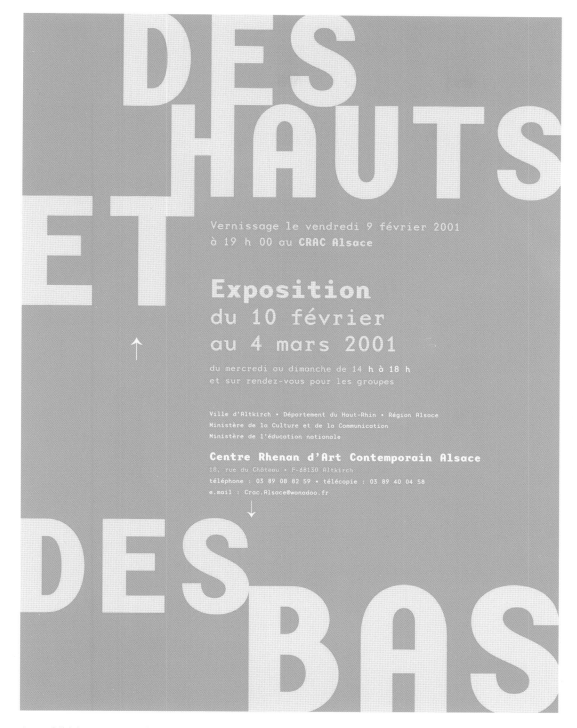

DES HAUTS ET DES BAS

Vernissage le vendredi 9 février 2001
à 19 h 00 au **CRAC Alsace**

Exposition
du 10 février
au 4 mars 2001

du mercredi au dimanche de 14 h à 18 h
et sur rendez-vous pour les groupes

Ville d'Altkirch • Département du Haut-Rhin • Région Alsace
Ministère de la Culture et de la Communication
Ministère de l'éducation nationale

Centre Rhenan d'Art Contemporain Alsace
18, rue du Château • F-68130 Altkirch
téléphone : 03 89 08 82 59 • télécopie : 03 89 40 04 58
e.mail : Crac.Alsace@wanadoo.fr

Art exhibition poster ı Olivier Umecker. In this poster for an
exhibition featuring young artists, the client did not wish to
include any images and proposed a more typographical type of
design on a plain colored surface. The font used is BaseMonospace
Wide, designed by Zuzanna Licko.

PANTONE 224 C

PANTONE COOL GRAY 2 C

PANTONE 228 U

PANTONE BLACK U

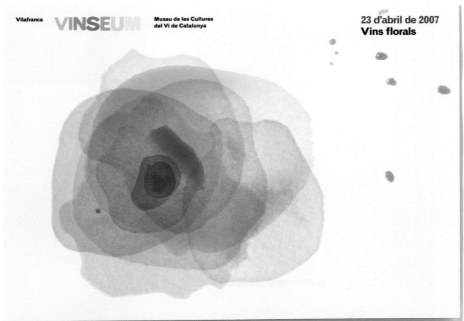

Vinseum I Estudio Diego Feijóo. A crimson color, very similar to the color of wine, was used by the Estudio Diego Feijóo to design the stationery items shown on this page, bottle label included. In this way, the viewer intuitively identifies with the product in question.

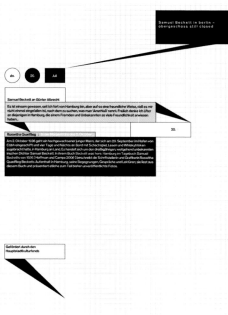

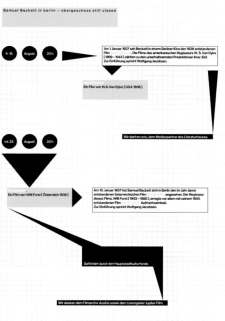

Samuel Beckett in Berlin ı Jung und Wenig. Geometric shapes like rectangles, circles, and triangles direct and guide the viewer's gaze in the correct order to read this promotional poster. The pink boxes help organize the information in order of importance and distinguish it between the various blocks of concepts.

PANTONE 254 U

PANTONE 443 U

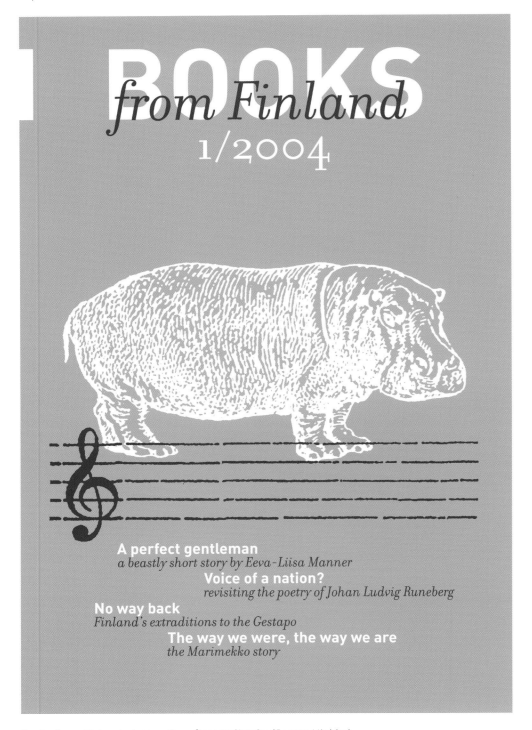

BOOKS
from Finland
1/2004

A perfect gentleman
a beastly short story by Eeva-Liisa Manner
Voice of a nation?
revisiting the poetry of Johan Ludvig Runeberg
No way back
Finland's extraditions to the Gestapo
The way we were, the way we are
the Marimekko story

Books from Finland 1/2004 ı Graafiset Neliöt Oy (Jorma Hinkka).
The cover of this literary journal plays with a style that the reader
will immediately associate with the world of letters and books:
classic typefaces, italics, illustrations without a context,
a minimalist use of color, dull or subdued colors, etc.

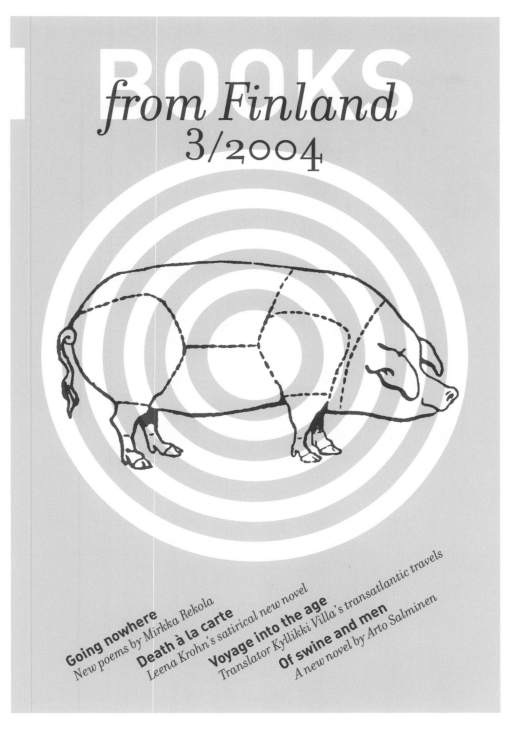

BOOKS
from Finland
3/2004

Going nowhere
New poems by Mirkka Rekola
Death à la carte
Leena Krohn's satirical new novel
Voyage into the age
Translator Kyllikki Villa's transatlantic travels
Of swine and men
A new novel by Arto Salminen

Books from Finland 3/2004 ı Graafiset Neliöt Oy (Jorma Hinkka).
What color should be chosen for a poster whose main image is
a pig divided into different portions? Obviously, pale pink—the
color of the pig's flesh. There is no logical link between the pig
and the subject of the poster, i.e. books. The association is purely
surrealist and attempts to surprise the spectator.

PANTONE 495 U

PANTONE 2935 U

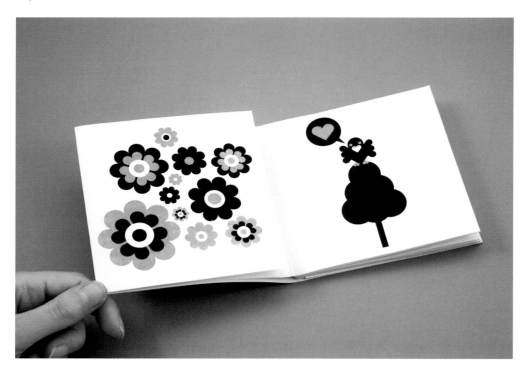

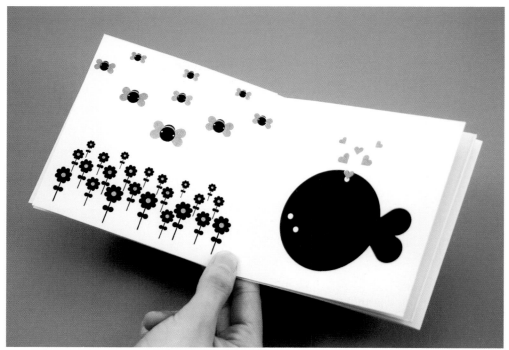

All Is Full of * ı Transfer Studio. Reduced to a maximum level of abstraction, the flowers, birds, and whales illustrated in this leaflet, which pays tribute to graphic minimalism, only require a touch of color to give the viewer the feeling of an atmosphere that is childlike, naïve, and innocent.

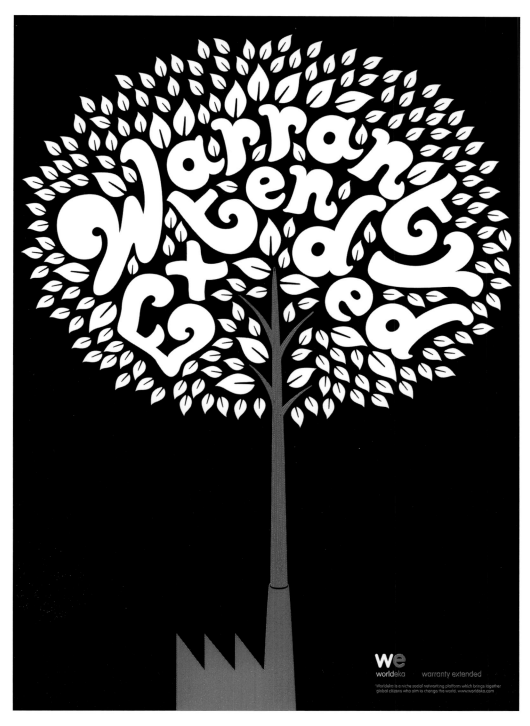

Worldeka. Warranty Extended ı Landor. Warranty Extended is the subject of a poster promoting the Worldeka brand, a social networking platform connecting people with common interests with the aim of bringing about collective change. Magenta is their corporate color.

worldeka

worldeka

worldeka

worldeka

worldeka

worldeka

worldeka

worldeka

worldeka

worldeka

worldeka

worldeka

worldeka

Worldeka identity system ı Landor. A strong visual style was chosen to spread the word internationally about the Worldeka social network. Using illustration and the color magenta has become the hallmark of the company, as it portrays its revolutionary spirit directly and with great clarity.

kontrolle ist gut, vertrauen ist besser

EROEFFNUNG: SA. achter MAERZ zwanzig uhr

BAR IM LFN nachbau eins:eins

DAUER neunter MAERZ bis siebzehnter APRIL zweitausendacht

MITTWOCH–SAMSTAG elf bis achtzehn uhr

F.A.G. zu Gast im

LADENFUERNICHTS

**spinnereistrasse sieben
nullviereinssiebenneunleipzig**

Fobbe ɪ Jung und Wenig. The information contained in this poster for an exhibition by Fabian Fobbe is divided into blocks by alternating between the colors of black and pink, without resorting to a basic grid format or using elements outside the text itself. The difference in the size of lettering enhances the idea of this hierarchy.

PANTONE 812 C

PANTONE BLACK C

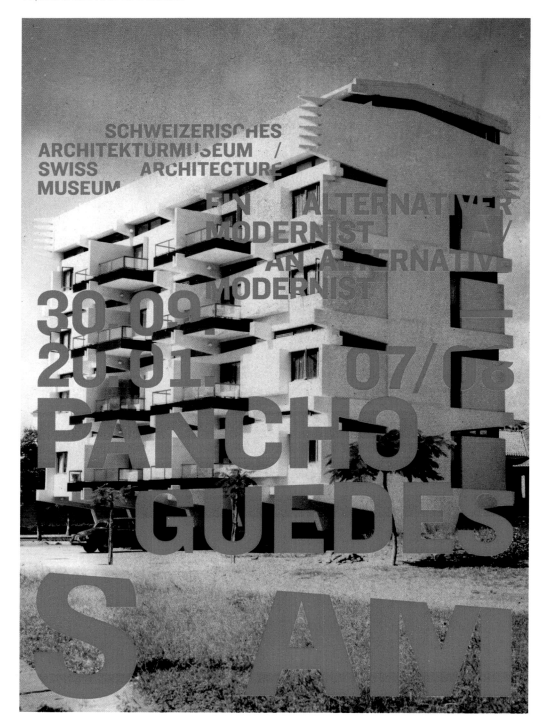

Pancho Guedes ı Claudiabasel. The warm tone of the text pushes the image into the visual background. The text interacts with the image and becomes part of it, taking its shape from the lines of perspective of the latter. The color chosen alludes to the warm tones found in this artist's work.

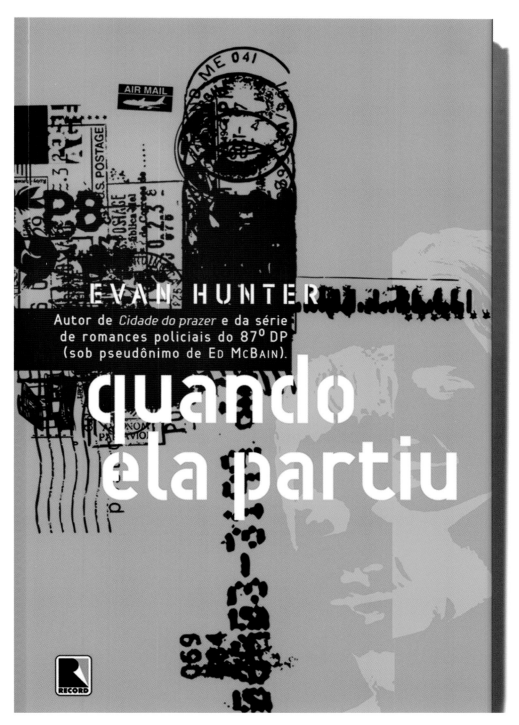

EVAN HUNTER

Autor de *Cidade do prazer* e da série
de romances policiais do 87º DP
(sob pseudônimo de ED MCBAIN).

quando
ela partiu

Quando ela partiu ı Laboratório Secreto. With this cover
illustrating a novel, an attempt was made to convey a sense of
emptiness and solitude. To this end, an illustration was created
using postage stamps arranged to imitate the skyline of a large
city. The concept is enhanced by the use of a stenciled typeface.

PANTONE 812 C

PANTONE BLACK C

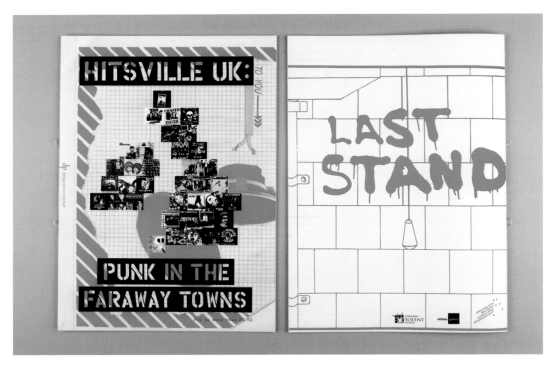

Hitsville UK ׀ Company. The design of this catalog and poster for an exhibition by Russell Bestley on the history of punk refers to the rough and tough aesthetics of this music genre using a palette of loud colors and a DIY atmosphere. The typeface is like the lettering achieved with spraypaint and stencil.

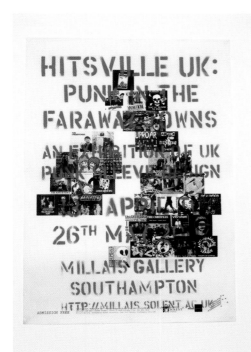

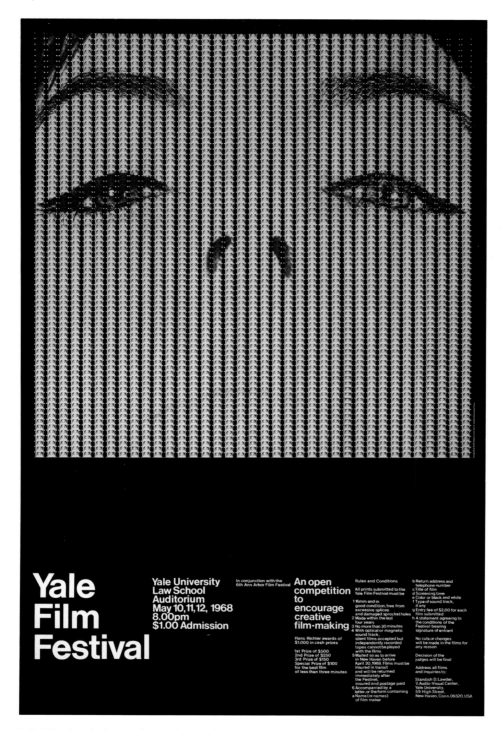

Yale Film Festival ı StudioWorks (Keith Godard). The face of a woman that occupies the main space in this poster is made up of 2,886 images of the same face each measuring 3 inches in height. The 2,886 images are arranged to form a larger version of the same face in purple. The Letraset font has been executed by hand in white.

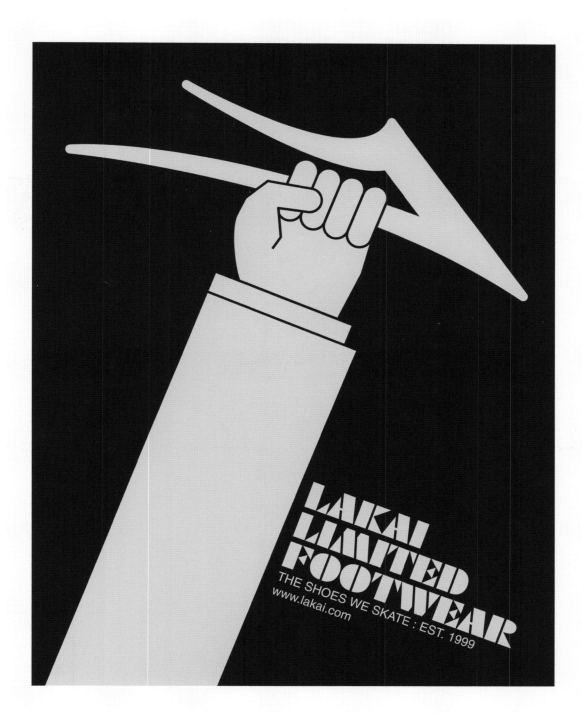

Lakai Limited Footwear poster ı OhioGirl Design (Andy Mueller).
An arm holding the Lakai brand logo mimics the populist
symbolism of the Soviet posters of the twentieth century. The
pink used for the arm against a navy blue background and the
abstract nature of the image warn the viewer of the poster's
parodic intention.

PANTONE 2365 C

PANTONE 2965 C

PANTONE 2395 C

PANTONE 396 C

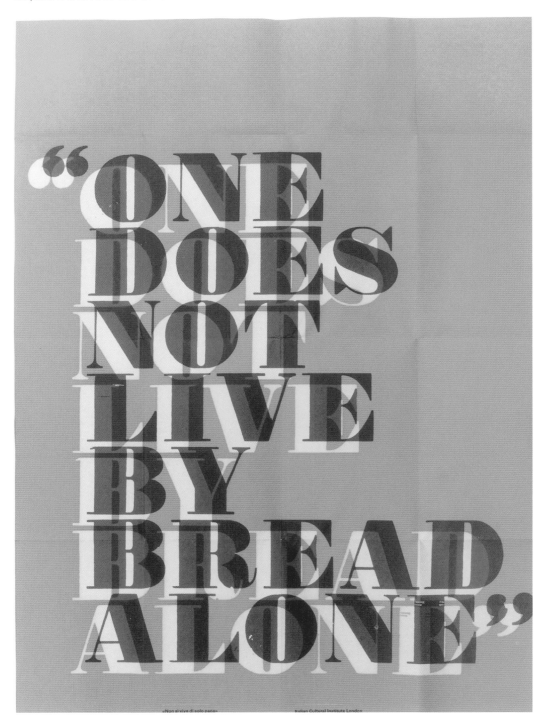

Italian Cultural Institute London ı Brighten the Corners, Ian Gabb. Poster for the Italian Cultural Institute in London. The combination of two warm colors gives spectacular results, leading the viewer to gaze at environments saturated with other striking elements.

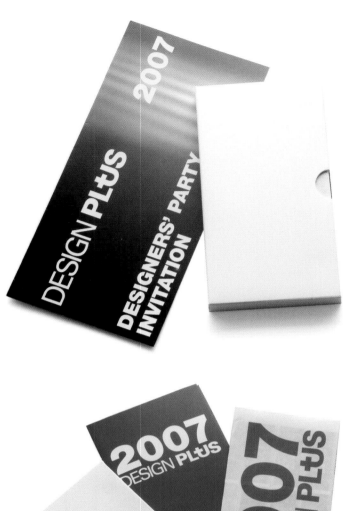

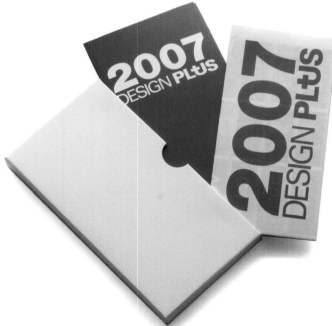

Design Plus 07 ı Double Standards. In this work for a design
competition, the use of a color progression (from black to purple)
avoids the monotony associated with using only two colors.
Simplifying the elements in the text to a maximum makes
the use of other colors completely unnecessary.

PANTONE 2587 C

PANTONE BLACK C

Scènes de Rentrée 2008 ı Pierre Vanni. In order to produce this leaflet for theater students in Toulouse, the designer asked them all to send him a photo of themselves. These were used to make up the front page in a simple, spontaneous format, in two colors.

PANTONE RHODAMINE RED C

PANTONE GREEN C

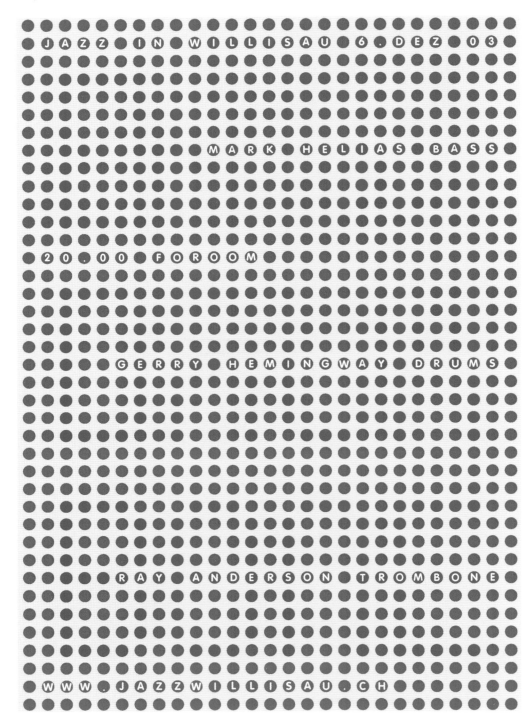

Bass Drum Bone ı Niklaus Troxler. Poster for a jazz concert given by a bassist, drummer, and trombone player. The design is based on dozens of dots in two colors; it is possible to read the information only if the reader stands back at a distance from the poster.

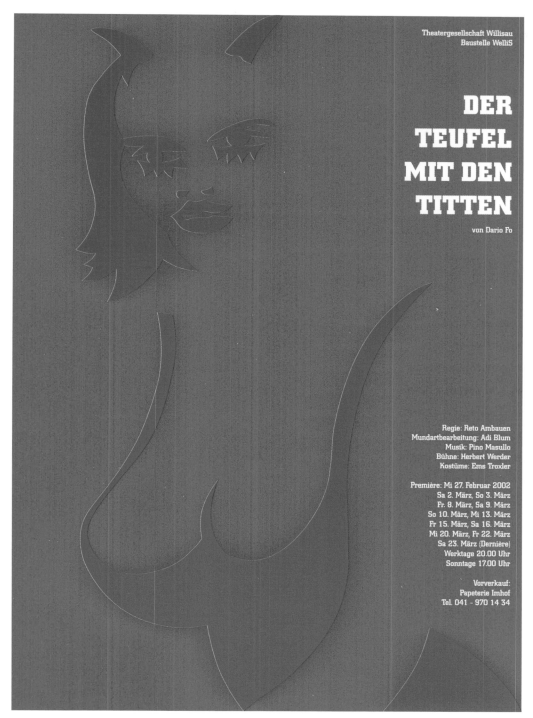

Theatergesellschaft Willisau
Baustelle WelliS

DER
TEUFEL
MIT DEN
TITTEN

von Dario Fo

Regie: Reto Ambauen
Mundartbearbeitung: Adi Blum
Musik: Pino Masullo
Bühne: Herbert Werder
Kostüme: Ems Troxler

Première: Mi 27. Februar 2002
Sa 2. März, So 3. März
Fr. 8. März, Sa 9. März
So 10. März, Mi 13. März
Fr 15. März, Sa 16. März
Mi 20. März, Fr 22. März
Sa 23. März (Dernière)
Werktage 20.00 Uhr
Sonntage 17.00 Uhr

Vorverkauf:
Papeterie Imhof
Tel. 041 - 970 14 34

Der Teufel mit den Titten ı Niklaus Troxler. The green illustration at the center of this poster alludes to the title of a play. Not only does the illustration create a bright contrast with the red background, it also engages the viewer's attention with little effort.

PANTONE RHODAMINE RED C

PANTONE BLACK C

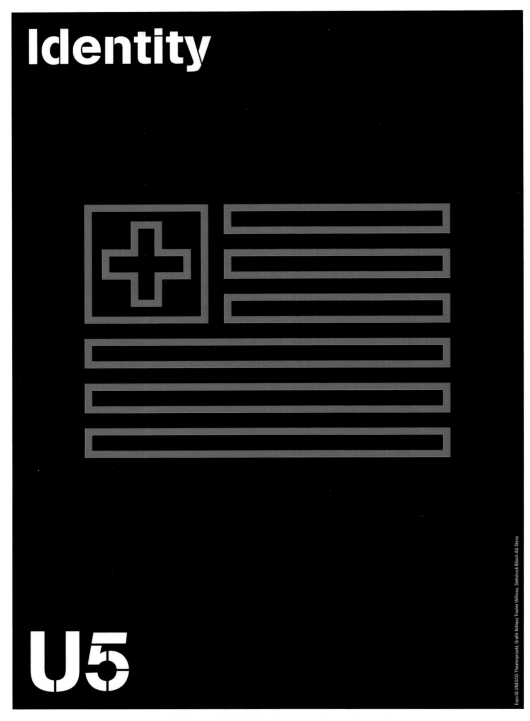

U5 Identity ı Niklaus Troxler. Poster for a play for UNESCO at the Swiss National Exhibition. The play is about Swiss people living abroad. Hence the hybrid flag and the use of colors that nobody, in principle, would associate with Switzerland.

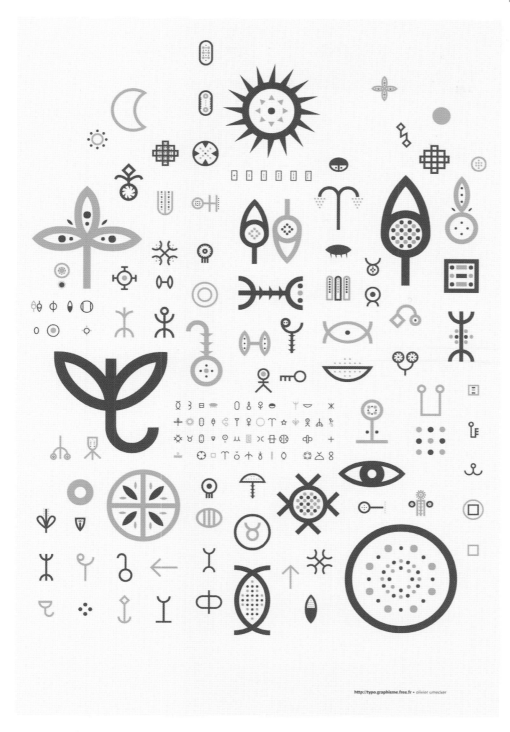

http://typo.graphisme.free.fr • olivier umecker

Promotional poster of a symbol font ı Olivier Umecker. The Yisana typeface, designed by Olivier Umecker, is a font made up of symbols inspired by African writing. The point of using only two colors in the poster promoting the typeface is to have the reader focus their attention on the symbols rather than the color scheme.

PANTONE VIOLET C

PANTONE BLACK C

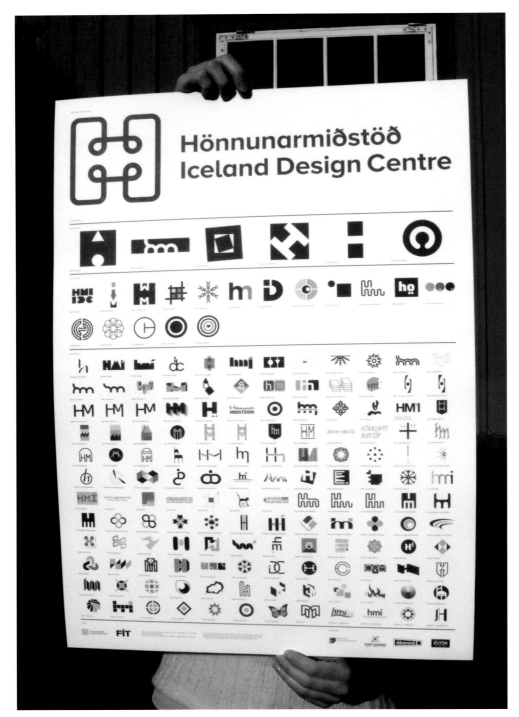

Iceland Design Centre ı Hörður Lárusson. In light of all the icons to be found in this poster designed by Hörður Lárusson for the Iceland Design Centre, there is only one possible choice: to reduce the use of any decorative elements to an absolute minimum and go for a palette with just two corporate colors.

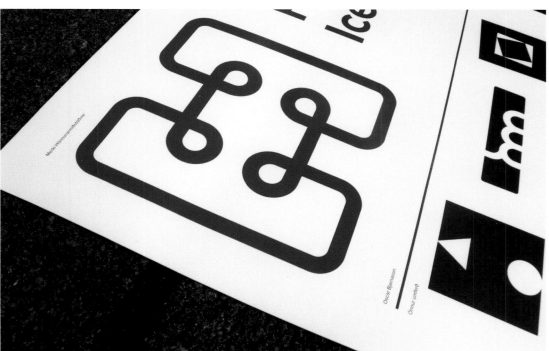

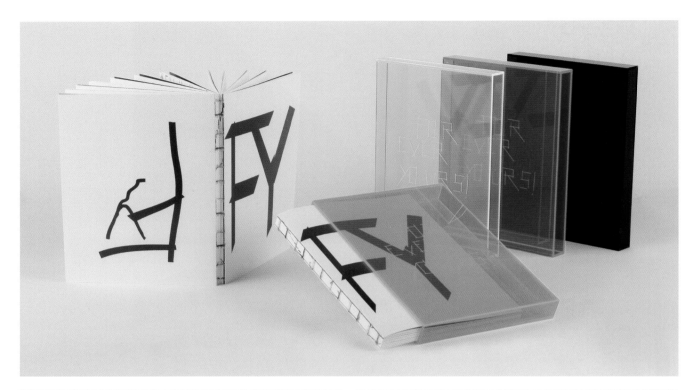

Forever Yours! ı Nicole Jacek. The concept of uniqueness in this book, which talks about the need for individuality as opposed to mass production, is expressed through the custom-designed fonts, plastic paper, and Plexiglas boxes used to hold them.

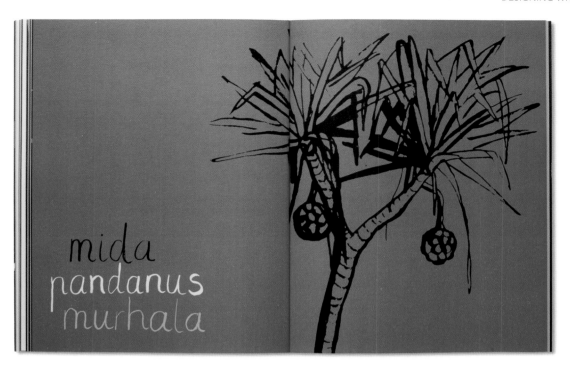

mida
pandanus
murhala

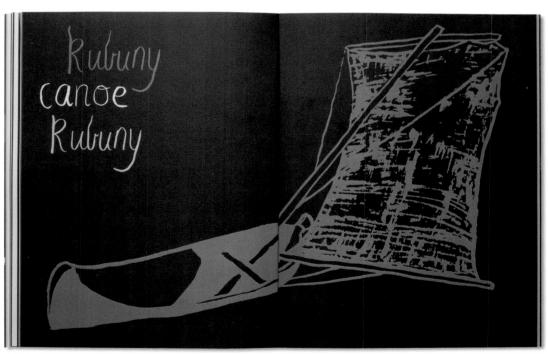

Rubuny
canoe
Rubuny

Majila Inkawart book ı David Lancashire Design. The first
publication in Marrku, the traditional language of Croker Island,
located off the coast of northern Australia. The work includes
illustrations portraying the key events in the stories and linguistic
analyses of the Marrku language.

PANTONE 285 C

PANTONE BLACK 4 C

PANTONE 286 C

PANTONE RED 032 C

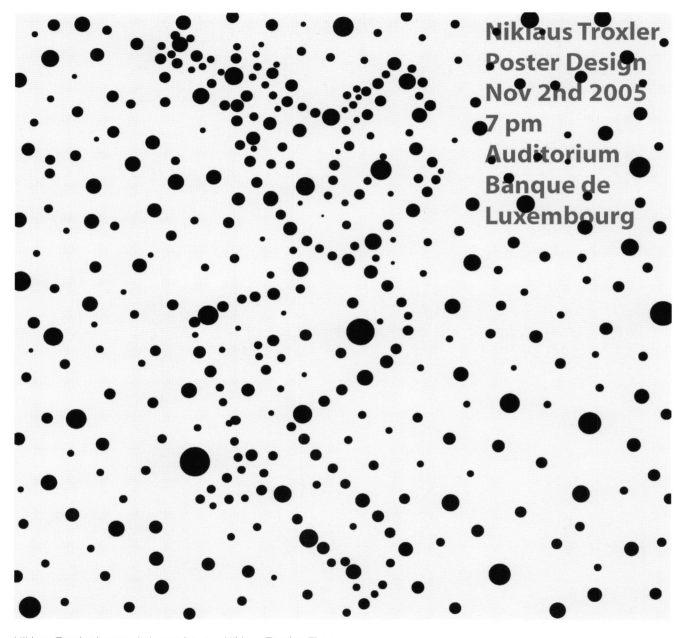

Niklaus Troxler
Poster Design
Nov 2nd 2005
7 pm
Auditorium
Banque de
Luxembourg

Niklaus Troxler lecture in Luxembourg ı Niklaus Troxler. The text
with the information on the event in this poster for a lecture by
the designer himself has been shifted to the right-hand margin,
whereas the background consists of an illustration made up of
a number of dots of different sizes.

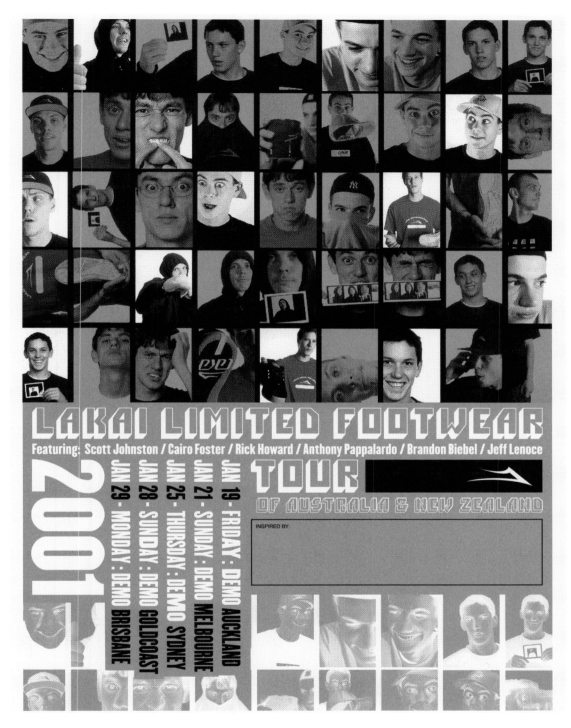

Australia ı OhioGirl Design (Andy Mueller). This poster promoting the Australian tour for the Lakai brand achieves its dynamic effect by means of a composition based on a grid containing photos of the exhibition's principal exponents. The photos are repeated at the bottom of the poster in negative format on a gray background.

PANTONE 291 C

PANTONE BLACK C

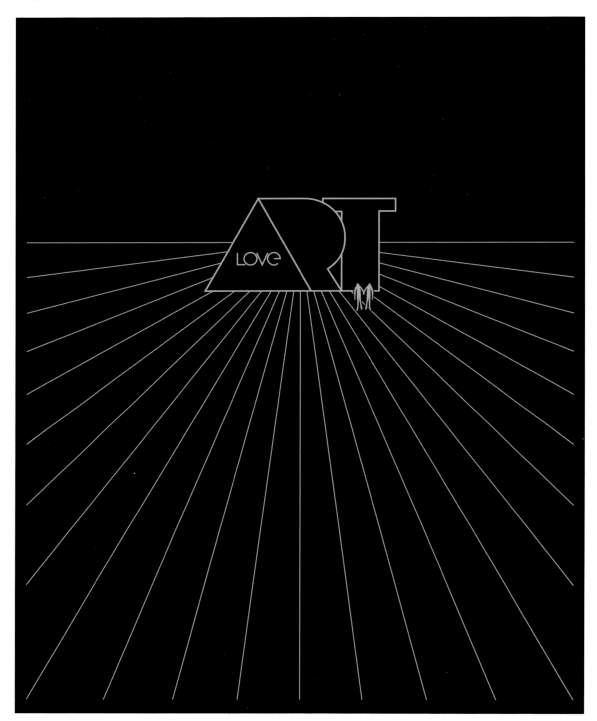

Love Art ׀ OhioGirl Design (Andy Mueller). With its clear allusions to a retro style, this promotional poster takes the viewer back to the 1980s. Against a landscape with an exaggerated vanishing point, the logo appears huge in the center of the poster.

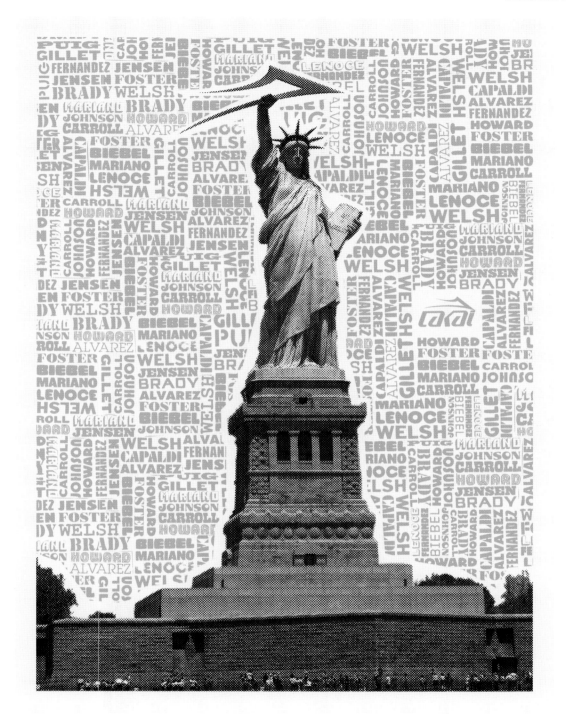

Lakai Limited Footwear poster ı OhioGirl Design (Andy Mueller).
The Lakai brand of sports footwear relies on the transgression
of some very familiar symbols: in this case, the Statue of Liberty,
which is holding the brand's logo, silhouetted by the names of the
skaters associated with the company.

PANTONE 297 C

PANTONE 444 C

NO CONTAMINES EL AIRE NO CONTAMINES EL AIRE NO CONTAMINES EL AIRE NO CONTAMINES EL AIRE *(the same phrase repeated over and over again, filling the entire panel)*

Contaminación del aire ı Félix Beltrán. The same phrase repeated over and over again on a blue background ends up forming a pattern that, in itself, becomes an illustration. The limited capacity of gray to contrast with blue lends depth to the composition.

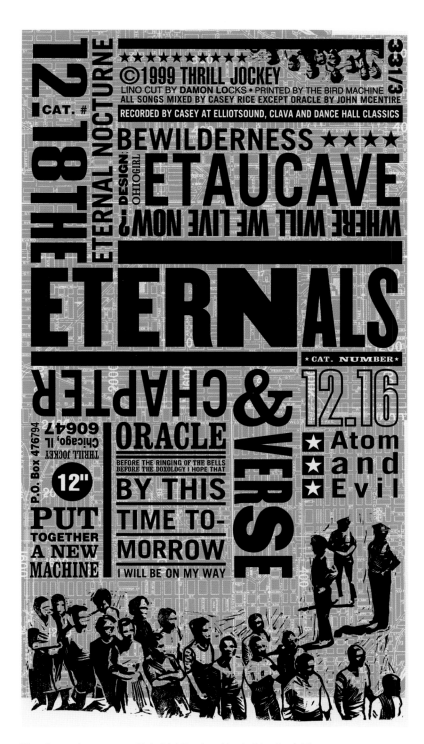

The Eternals poster ı OhioGirl Design (Andy Mueller). The streetplan of Chicago on a blue background forms the backdrop for this poster promoting the band The Eternals. The black lettering, which in another color would be drowned by the baroque background, enables the viewer to read the text without any problem.

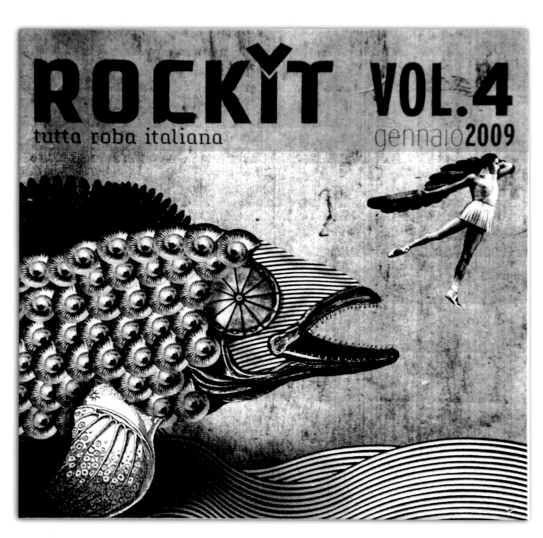

Rockit ı Alessandro Maffioletti. For this cover for a compilation CD of Italian indie bands, a digital collage was created from images extracted from an old encyclopedia. Black and white contrast sharply with the bluish border running across the top of the CD cover.

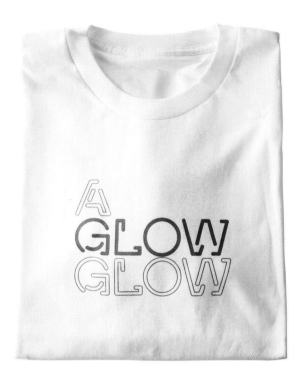

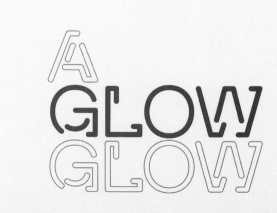

A-Glow-Glow Macro Media Arts Exhibition ı Milkxhake. To portray
the light concept for the A-Glow-Glow Exhibition products and
logo, the designers made use of a typeface that simulates the
effect of neon lighting and the colors cyan and purple.

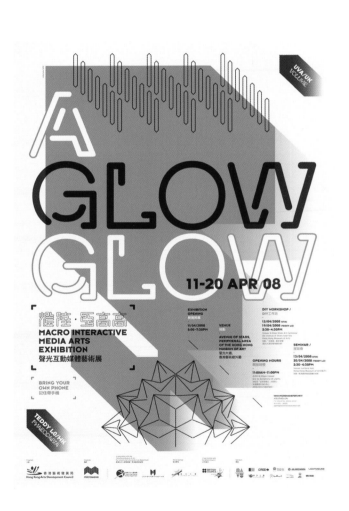

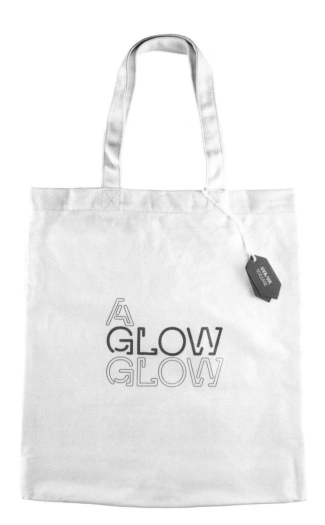

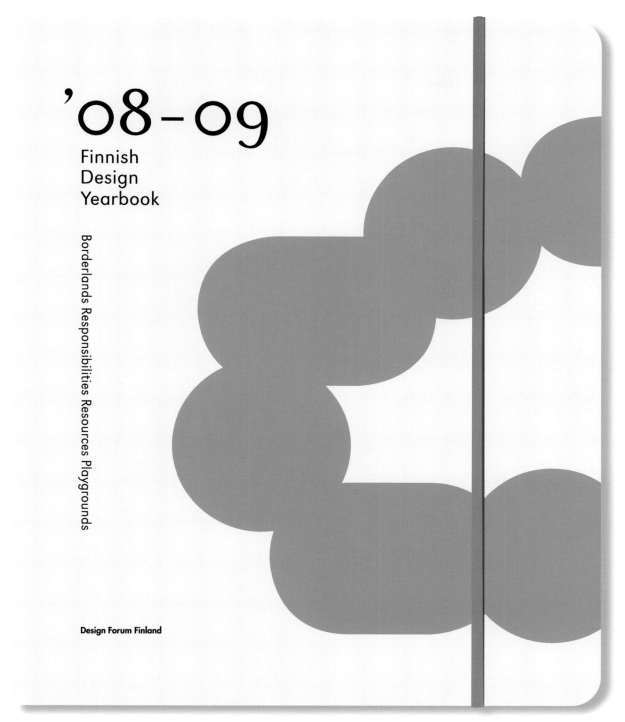

'08–09
Finnish
Design
Yearbook

Borderlands Responsibilities Resources Playgrounds

Design Forum Finland

Finnish Design Yearbook 2008-2009 ı Dog Design. A simple
monochrome shape in a constant state of flux functions as the
logo and graphic motif for this catalog. The pure and refreshing
shade of blue chosen by Dog Design symbolizes minimalist Finnish
design in general.

PANTONE 311 C

PANTONE BLACK C

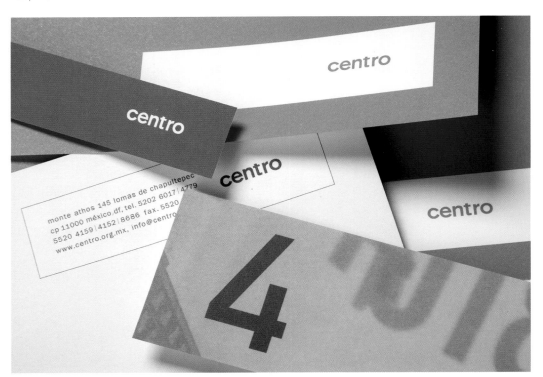

Centro ı Blok. Gradually softening the intensity of a single color offers the artist a wider palette to choose from. As can be seen here, this wide palette enables the designer to play with the images and create complex decorative backdrops.

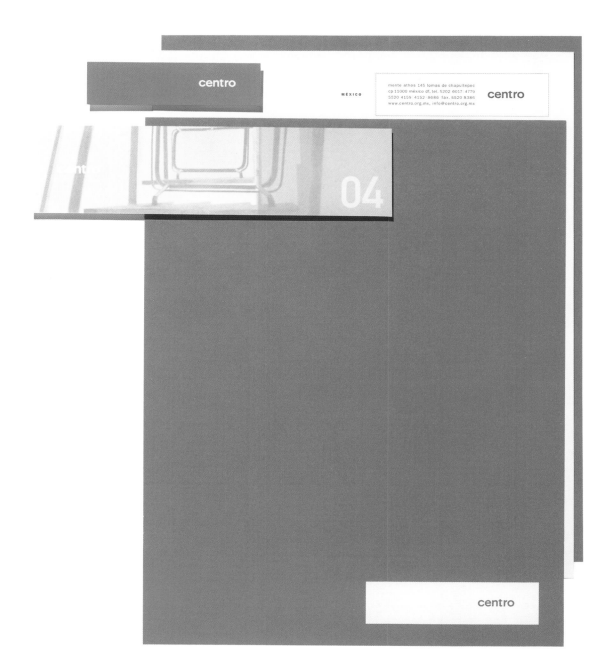

PANTONE 312 U

PANTONE 7532 U

PANTONE 312 C

PANTONE BLACK C

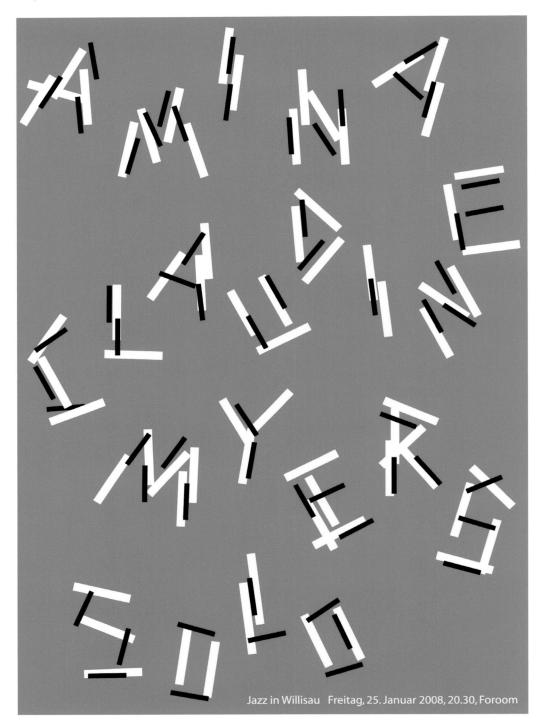

Jazz in Willisau Freitag, 25. Januar 2008, 20.30, Foroom

Amina Claudine Myers ı Niklaus Troxler. In this poster for a jazz concert by pianist Amina Claudine Myers, the sole subject of the composition is the typeface. The design draws its inspiration from the black and white keys of the piano, which become the building blocks for each letter.

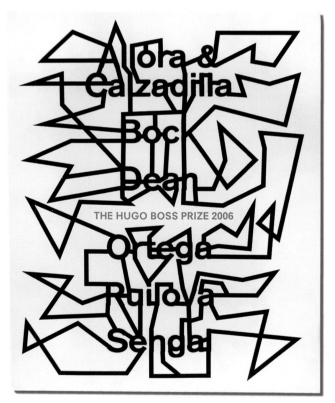

The Hugo Boss Prize ı Karlssonwilker. For this poster announcing the Hugo Boss Prize, the brand specified pale blue be used as the design's main color. The rest was completely open to design. The result was a two-color palette of blue and black.

PANTONE 546 C

PANTONE 192 C

Culturescapes Festival ı Claudiabasel. The two colors in this poster promoting the Culturescapes Festival allow the artist to play with the text and thus fulfill one of its essential requirements, namely, the need for the poster to be written in two different languages, without one language being more eye-catching than the other.

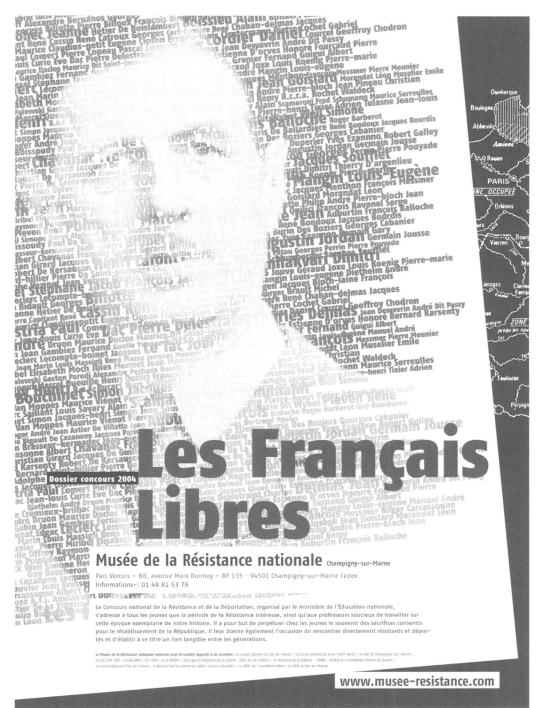

Les Français Libres **ı** Olivier Umecker. In this poster for an exhibition on General De Gaulle, the design was based on the colors of the French national flag (blue, white, and red), the general's portrait, and the title Les Français Libres. The font used here is Fago, designed by Ole Schäfer.

PANTONE 549 C

PANTONE 193 C

PANTONE 549 U

PANTONE 877 U

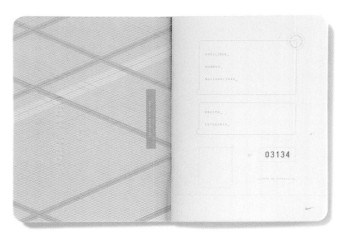

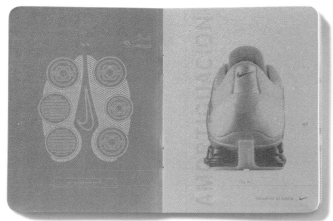

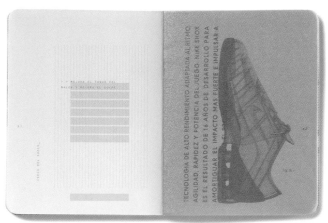

Nike Passport ı Blok. Nike's promotional elements respect the brand's aesthetic style and are immediately associated with its products and color schemes. This idea is best exemplified by the Nike Passport, the design of which relies on two pastel shades of color to convey brand identity.

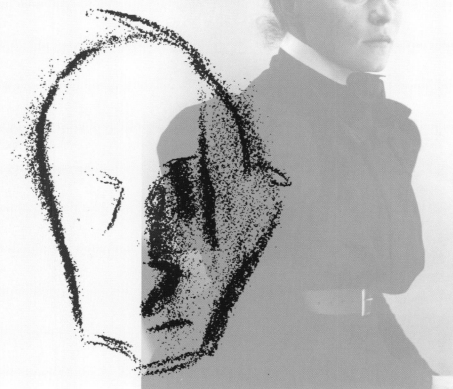

BOOKS
from Finland
3/2003

Face to face
the extraordinary art of Helene Schjerfbeck
Low-life Helsinki
a new Harjunpää thriller by Matti Yrjänä Joensuu
Tools for enlightenment?
new poetry by Joni Pyysalo
Neighbourly relations
300 years of Finland and St Petersburg

Books from Finland 3/2003 ı Graafiset Neliöt Oy (Jorma Hinkka).
The use of two colors on the cover of the literary journal *Books from Finland* enables the artist to play with two visual levels: one for the schematic illustration, seemingly drawn in chalk, and the other for the photograph.

PANTONE 658 U

PANTONE 241 U

Here Comes the Future ı OhioGirl Design (Andy Mueller). By playing with the confusion caused by overlaying two different slogans ("The future is now!" and "Here comes the future"), Ohiogirl Design make the viewer perceive their promotional artwork as a game and try to work out the meaning.

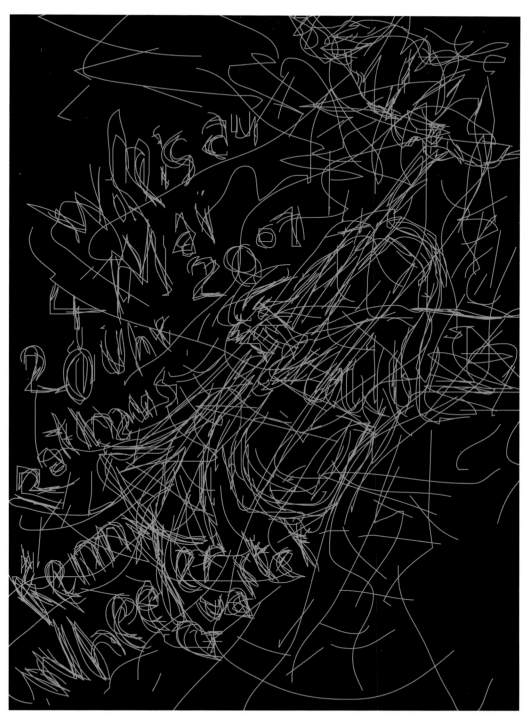

Kenny Wheeler Quartet ı Niklaus Troxler. Designed with the computer program Adobe Illustrator and only using the mouse, this poster for a jazz concert was the product of an attempt to achieve a very spontaneous design, as if drawn by hand, to convey the concept of improvisation typical of this type of music.

PANTONE 801 C

PANTONE BLACK C

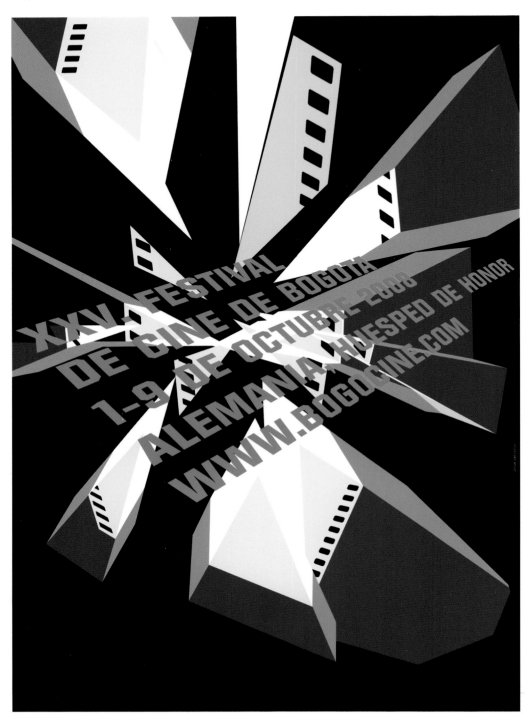

25th Film Festival Bogota ı Uwe Loesch. The biggest problem
encountered when designing this poster for a film festival was
how to position the twenty-five logos and eight names of the
sponsors (in gray) without being detrimental to the design itself.
The original design (without the logos) is the one seen here on this
page.

AKZIDENZ GROTESK H. BERTHOLD AG 1896

MUSEUM FÜR DRUCKKUNST
NONNENSTR. 38
04229 LEIPZIG

Museum

F. DRUCK 1234
KUNST 04229
The ABCleipzig
DEFGHIijklmnopq
JKLMNOstuvwxyz
PQRSTU+
VWXYZ
schrift Ak zidenzGr otesk.

LIGHT *LIGHTITALIC* NORMAL *ITALIC* MEDIUM *MEDIUMITALIC* **BOLD** ***BOLDITALIC*** **BLACK**

24 pt 24 pt

ÖFFNUNGSZEITEN:
MONTAG – FREITAG
10:00 – 17:00 H
SAMS. GESCHLOSSEN
SONNTAG
11:00 – 17:00 H

WWW.DRUCKKUNST-MUSEUM.DE

ÖFFNUNGSZEITEN:
MONTAG – FREITAG
10:00 – 17:00 H
SAMS. GESCHLOSSEN
SONNTAG
11:00 – 17:00 H

MUSEUM FÜR DRUCKKUNST
NONNENSTR. 38
04229 LEIPZIG

MUSEUM FÜR DRUCKKUNST
NONNENSTR. 38
04229 LEIPZIG

EIN MUSEUM ZUM ANFASSEN UND MITMACHEN. 500 JAHRE
DRUCKGESCHICHTE AUF VIER ETAGEN IN WERKSTATT-
ATMOSPHÄRE ERLEBEN.
FACHLEUTE FÜHREN DIE HISTORISCHEN MASCHINEN
JEDERZEIT VOR

Grotesk ı Jung und Wenig. This series of posters for the Museum
of Graphic Arts in Leipzig pays tribute to the Ad Grotesk typeface,
much appreciated by designers thanks to its clean design,
based entirely on typography and devoid of any kind of image or
ornamentation.

PANTONE 801 C

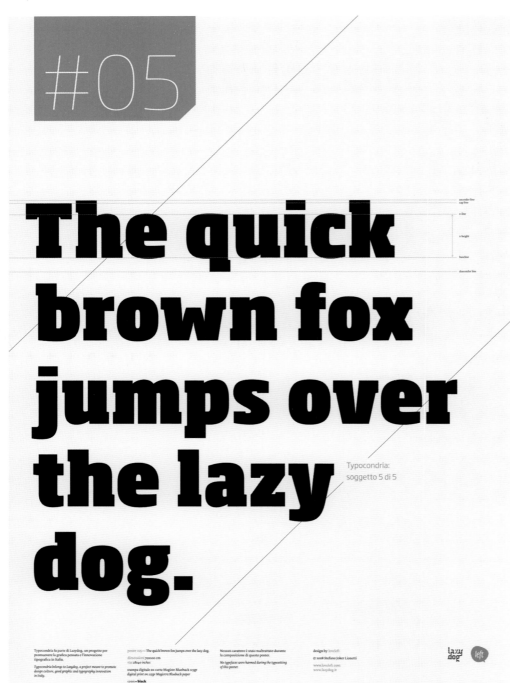

Typocondria:
soggetto 5 di 5

Typocondria fa parte di Lazydog, un progetto per
promuovere la grafica pensata e l'innovazione
tipografica in Italia.

*Typocondria belongs to Lazydog, a project meant to promote
design culture, good graphic and typography innovation
in Italy.*

poster #05— The quick brown fox jumps over the lazy dog.

dimensioni 70x100 cm

size 28x40 inches

stampa digitale su carta Magistr Blueback 115gr
digital print on 115gr Magistra Blueback paper

cyan ● **black**

Nessun carattere è stato maltrattato durante
la composizione di questo poster.

*No typefaces were harmed during the typesetting
of this poster.*

design by loveleft
© 2008 Stefano Joker Lionetti
www.loveleft.com
www.lazydog.it

Typocondria #05 ı Loveleft. According to the Loveleft designers,
the true secret of the design of this limited series of five posters
on typography and graphic design lies in applying very little color,
and in the wise choice of a good typeface.

PANTONE BLACK C

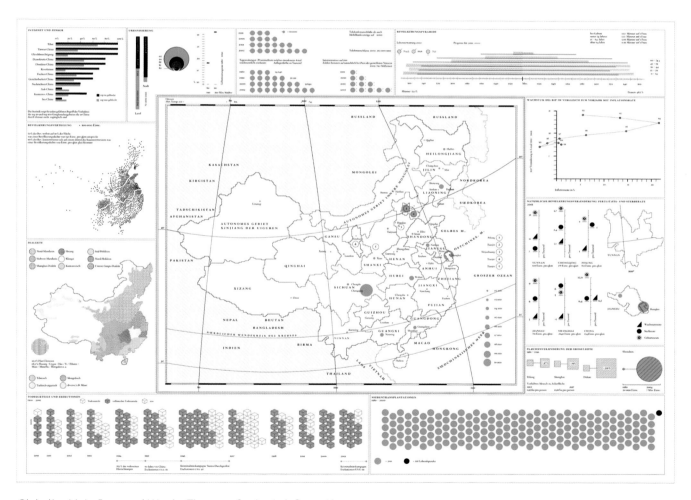

Globalize Me! ı Jung und Wenig. The use of color in informative
diagrams and statistic charts enables the basic information on a
specific subject to be extracted at first glance. The colored dots
also function as focal points in the composition.

PANTONE 801 C

PANTONE BLACK C

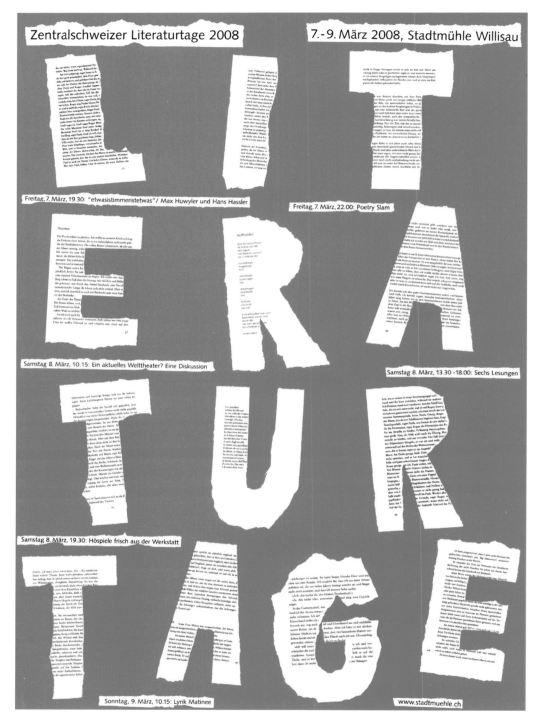

Literaturtage ׀ Niklaus Troxler. Poster for cycle on literature. The typeface has been created by hand by tearing up sheets of paper taken from the books of the writers participating in the event. The use of just two colors reinforces the austere and rough effect of the typeface.

PANTONE 801 C

CLEMENS MEYER

DIE NACHT, DIE LICHTER

stories

S. Fischer Verlag

freitag vierzehn. drei. zweitausendundacht einundzwanzig Uhr

LESUNG LADENFUERNICHTS

spinnereistrasse sieben halle achtzehn nullviereinssiebenneun eipzig

C. Meyer ı Jung und Wenig. By harnessing all the opportunities to be had from using just two colors in this poster encouraging people to read the book *Die Nacht der Lichter* by Clemens Meyer, Jung und Wenig have injected energy into a design that would otherwise be lacking in visual tension.

PANTONE BLACK C

Freeman College ı Company. A yearbook for the students in the final year of their university course, inspired by old exercise books. The handwritten responses of each student to a personal questionnaire have been scanned to create the idea of an album.

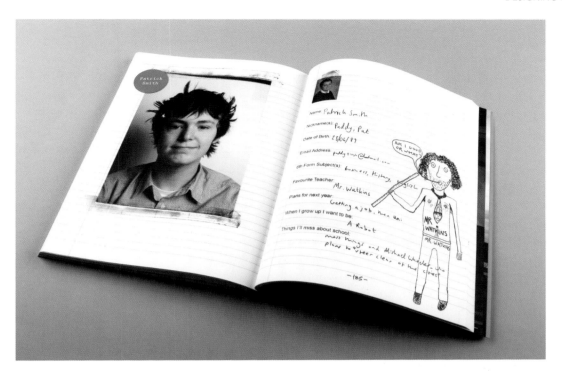

PANTONE 801 C

PANTONE BLACK C

One Degree
of awareness

Lots of small changes by every person will change the future of the planet.

One Degree is all about you. There are tips and tools to reduce your own carbon footprint and incentives to make tackling climate change a priority every day. We will report on what we're doing, what impact we're having and how we can achieve more. One Degree of change.

Ask the people around you or check out the website.
1degree.net.au

A News Limited Initiative 1degree.net.au

One Degree ı Landor. Created for a "green" company, this design combines the image of an employee with the figure 1 (a visual metaphor for "a person") and the symbol for degree, which also represents the thought bubble for each worker thinking about how to reduce carbon emissions by one degree.

One Degree
of separation

We are all individuals, but climate change affects all of us.
We need to work together to solve it.

One Degree is all about you. There are tips and tools to
reduce your own carbon footprint and incentives to make
tackling climate change a priority every day. We will report
on what we're doing, what impact we're having and how
we can achieve more. One Degree of change.

Ask the people around you or check out the website.
1degree.net.au

A News Limited Initiative 1degree.net.au

PANTONE 801 C

PANTONE BLACK C

PANTONE 2727 C

Undergraduate Exhibition
May 12–May 18
Opening Reception:
May 12, 5:30–8 p.m.
808 Commonwealth
Avenue
Hours: 1–5 p.m.
Tuesday–Sunday

Senior Exhibition
May 12–May 21
Opening Reception:
May 12, 5:30–8 p.m.
Boston University
Art Gallery
855 Commonwealth
Avenue
Hours: 10–5 p.m.
Tuesday–Friday
1–5 p.m.
Saturday and Sunday

2000

Visual Arts Student Exhibitions

MFA Sculpture
Duker Bower
Ted Southwick
Howard Tran
Jin Xu

Arts Education
Jonathan Stein, BFA
Arllen Acevedo, MFA
Marion Beram, MFA
Torrey Green, MFA
Leslie Mears, MFA
Stacey Piwinski, MFA
Donna Pobuk, MFA
Heather Richard, MFA
Phyllis Roybal, MFA
Vadis Turner, MFA

Exhibition
April 28–May 7
Opening Reception:
April 28, 5–8 p.m.
Boston University
Art Gallery
855 Commonwealth
Avenue
Hours: 10–5 p.m.
Tuesday–Friday
1–5 p.m. Saturday
and Sunday

MFA Graphic Design
Rose-Marie Gomez
Janet Kyunghwa Kim
Younhee Lim
Stuart Alan McCoy
Jennifer Shay McNamee
Seung-Yeon Oh
Jee-Won Paik
Nuri Gabriela Resnik
Eileen Rim
Adriana Sanchez-Mejorada
Christopher Sweet
Mark Allan Thomas
Susan Yoon Mi Yoon

MFA Painting
Heidy Chuang
Daphne Confar
Meg Flemming
Alfredo Gisholt
Nathan Grupposo
Laura Kivela
Nicholas B. Lamia
Steve McCall
Christopher McEvoy
Gabriel A. Phipps

Exhibition
May 9–May 21
Opening Reception:
May 12, 4–6 p.m. G.S.U.
775 Commonwealth
Avenue
Hours: 11–5 p.m.
Tuesday–Friday
1–5 p.m. Saturday
and Sunday

BOSTON UNIVERSITY

Exhibition
April 14–April 23
Opening Reception:
April 14, 6–8 p.m.
Boston University
Art Gallery
855 Commonwealth
Avenue
Hours: 10–5 p.m. Tuesday–Friday
1–5 p.m. Saturday and Sunday

Exhibition
April 28–May 7
Opening Reception:
April 28, 5–8 p.m.
808 Commonwealth
Avenue
Hours: 1–5 p.m.
Tuesday–Sunday

BU Visual Arts ı Richard B. Doubleday. For this poster for the Boston University announcing exhibitions by the institution's students in visual arts, it was decided to divide the poster into two symmetrical mirror images. Blue represents the visual arts.

PANTONE BLACK C

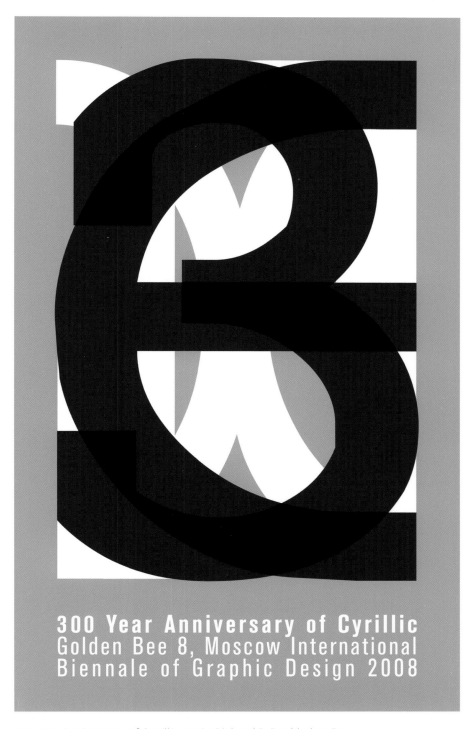

300 Year Anniversary of Cyrillic
Golden Bee 8, Moscow International
Biennale of Graphic Design 2008

300-Year Anniversary of Cyrillic 2008 ı Richard B. Doubleday. For
this poster announcing the three-hundred-year anniversary of the
Cyrillic alphabet, three characters have been laid over one another
to form the main illustration. This design is possible due to the use
of two shades of blue, which make the figure stand out without the
usual solution of resorting to the use of the color black.

PANTONE 2915 C

PANTONE 433 C

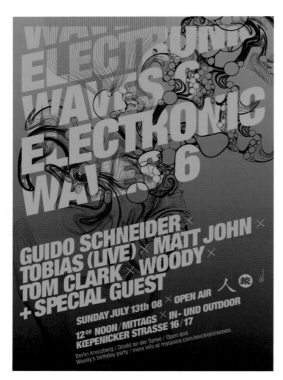

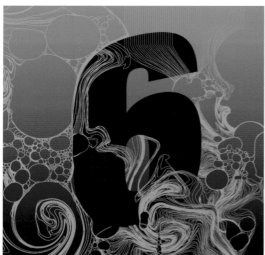

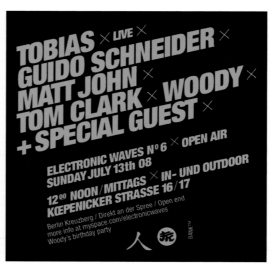

Electronic Waves ı BANK™. The color gradient (a classic resource when working with only one or two colors) places the viewer in the depths of the ocean, in keeping with the name of the deejay sessions printed on the poster ("electronic waves").

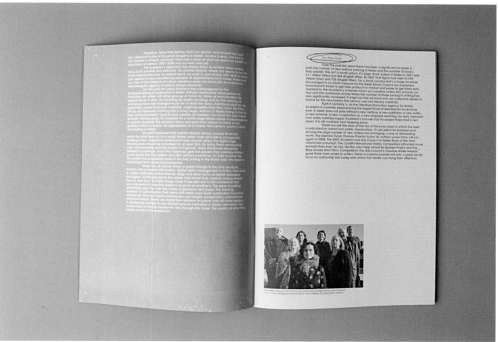

Academi ı Elfen. Conceived with the mere intention of celebrating the notebooks and exercise books used by academics over the years, in this design the illustrations and "handwritten" text give these very dense blocks of text a more light-hearted touch.

PANTONE 3105 C

PANTONE WARM GRAY 10 C

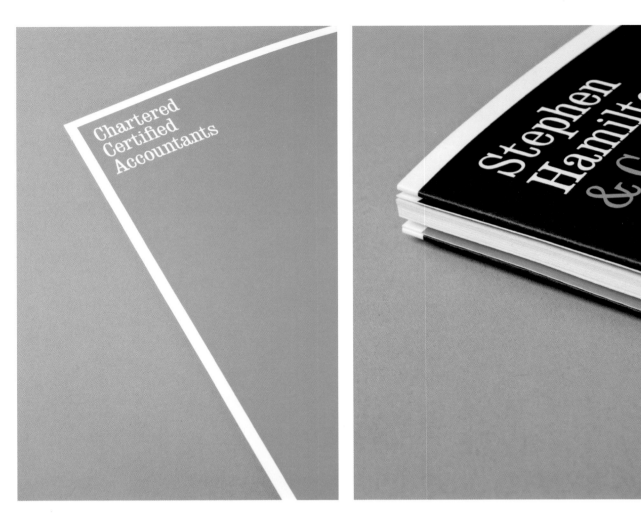

Stephen Hamilton ı Elfen. For the purposes of making this corporate identity symbolize the values and experience of the company, two complementary colors have been combined to represent the high quality service offered. The logo and the minimal use of typographic elements transmit the idea of a clear-cut identity.

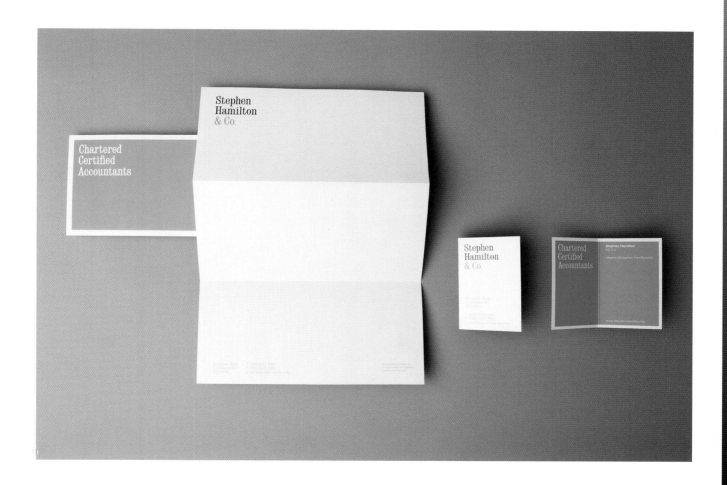

PANTONE 7472 C

PANTONE 255 C

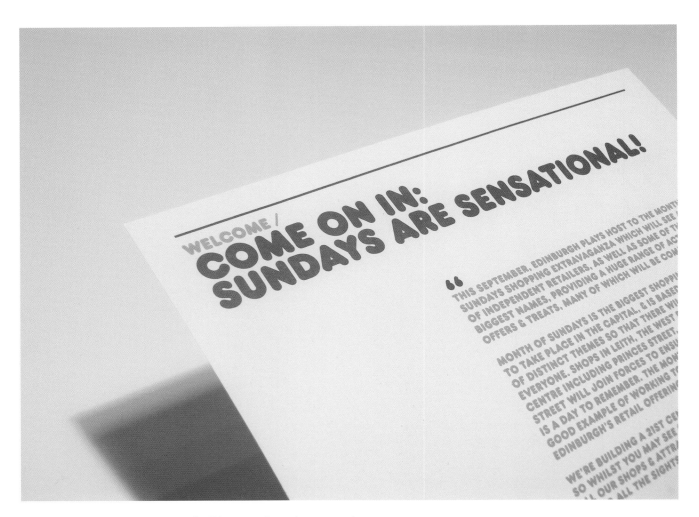

WELCOME /

COME ON IN: SUNDAYS ARE SENSATIONAL!

" THIS SEPTEMBER, EDINBURGH PLAYS HOST TO THE MONTH
SUNDAYS SHOPPING EXTRAVAGANZA WHICH WILL SEE
OF INDEPENDENT RETAILERS, AS WELL AS SOME OF TV
BIGGEST NAMES, PROVIDING A HUGE RANGE OF ACT
OFFERS & TREATS, MANY OF WHICH WILL BE COM

MONTH OF SUNDAYS IS THE BIGGEST SHOPPI
TO TAKE PLACE IN THE CAPITAL, & IS BASED
OF DISTINCT THEMES SO THAT THERE WI
EVERYONE. SHOPS IN LEITH, THE WEST
CENTRE INCLUDING PRINCES STREET,
STREET WILL JOIN FORCES TO ENSU
IS A DAY TO REMEMBER. THE MON
GOOD EXAMPLE OF WORKING T
EDINBURGH'S RETAIL OFFERING

WE'RE BUILDING A 21ST CE
SO WHILST YOU MAY SEE
L OUR SHOPS & ATTRA
ALL THE SIGHT

Month of Sundays program ı Touch. This two-color palette, together
with the childlike typeface and iconic illustrations, capture the
playful whimsy of the Month of Sundays, a kid-friendly events
program in the city of Edinburgh.

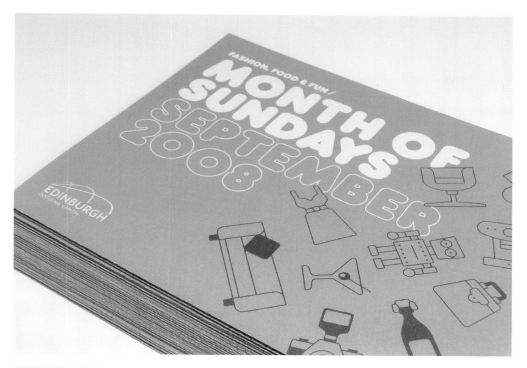

PANTONE 323 C

PANTONE 158 C

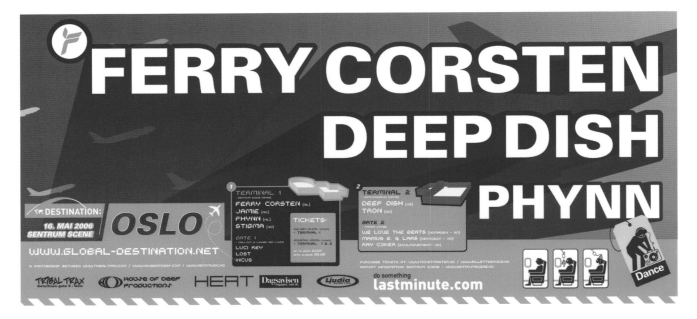

Destination poster ı Smogdog (Hans Gerhard Meier).
Poster promoting a party at a club in Oslo. The poster
measures 27 × 12 inches, and takes its design cues from
aesthetics associated with traveling.

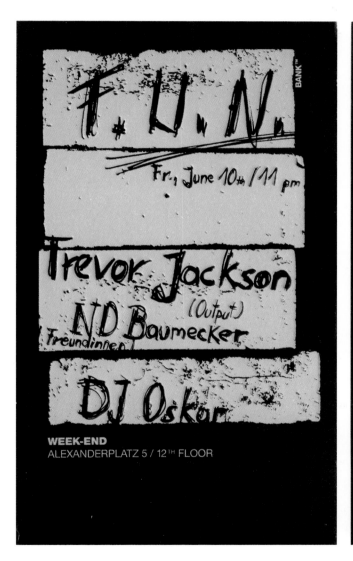

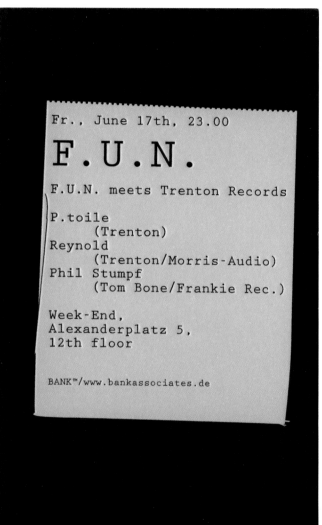

F.U.N. ı BANK™. Poster and flyer for the Berlin F.U.N. sessions.
Electronic music is considered to be cool and detached, and these
designs, with their use of pale green and black, are evocative of
the music's mechanical nature.

PANTONE 331 U

PANTONE 5185 U

F.U.N.
Fr., June 3rd / 23.00
The Glimmers (Eskimo/K7)
and Special Guest

Week-End/Alexanderplatz 5/12th floor
BANK™/www.bankassociates.de

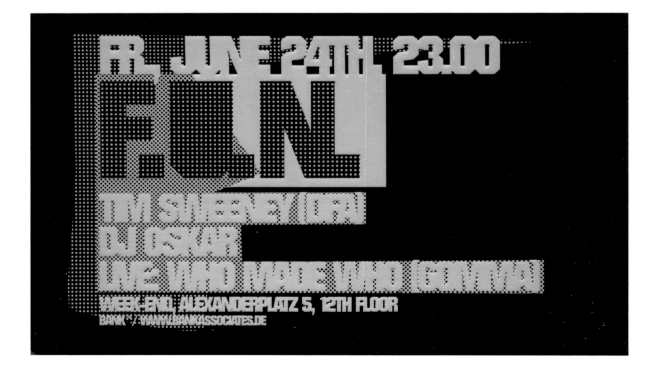

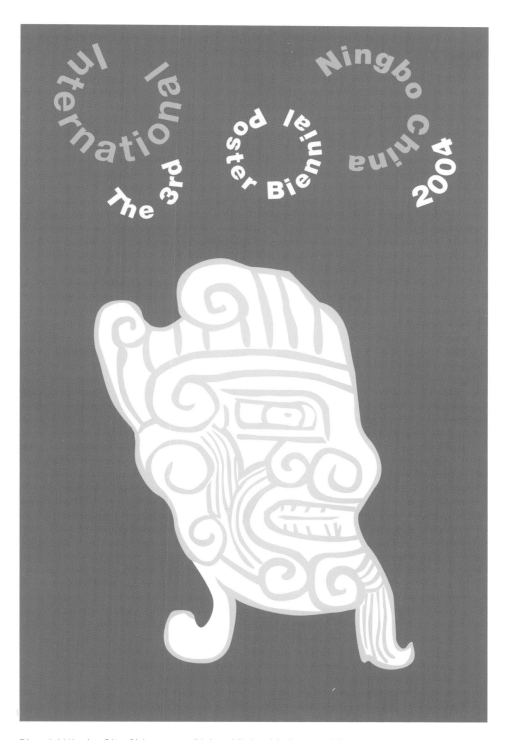

Biennial Ningbo City China 2004 ı Richard B. Doubleday. Legibility was not Richard B. Doubleday's chief concern when designing this poster for the Chinese poster biennial in 2004. The texts in the circle imitate the arabesques in the mask and endow the poster with a sense of equilibrium.

PANTONE 344 C

PANTONE 2583 C

PANTONE 354 C

PANTONE 300 C

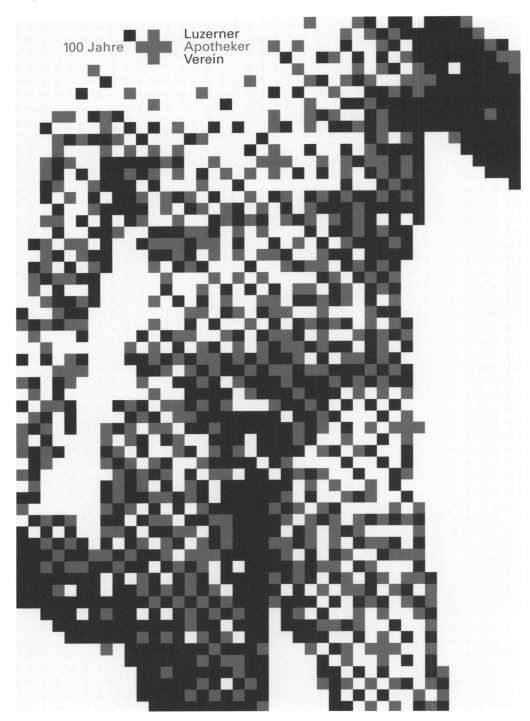

100 Jahre ✚ Luzerner Apotheker Verein

Apotheker Verein ꟷ Niklaus Troxler. This poster for the Swiss Pharmaceutical Association is based on its logo, in green and blue. The design portrays Michelangelo's *David* through a number of small squares.

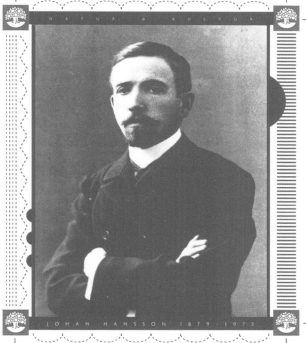

N&K poster ı Nille Svensson. In this promotional and informative poster for Natur & Kultur, one of the most important publishing houses in Sweden, it was decided to use a photo of the founder on the front and reserve the back for the description of the company.

PANTONE 360 C

PANTONE BLACK C

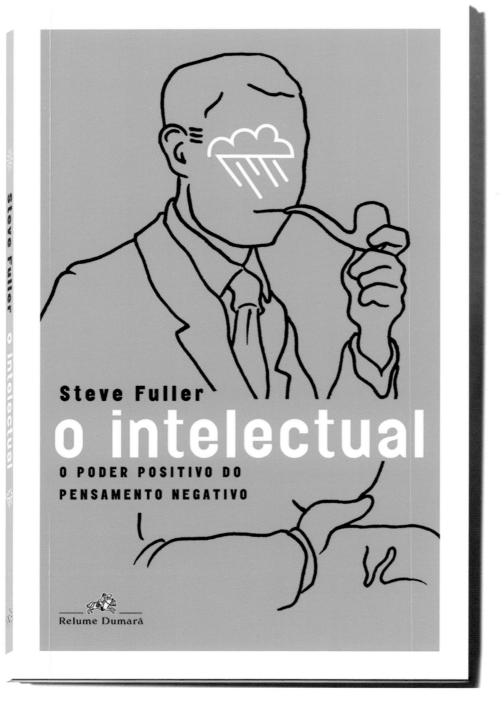

O inteletual | Laboratório Secreto. The concept of brainstorming is the main idea for the cover of this book by Steve Fuller. The humorous innuendo in the subtitle is enhanced by the hand-drawn illustration and is expressed through a single color, housed inside a white frame.

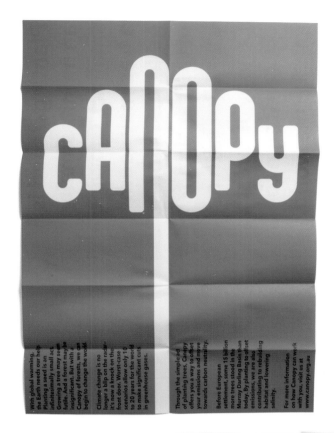

Canopy ı Parallax. In order to make the design convey the environmental concept espoused by Canopy in a visual, metaphorical way, a business card/poster was designed that could be opened to reveal the company's various details and information. The right stroke of the "N" symbolizes a growing tree.

PANTONE 360 C

PANTONE BLACK C

PANTONE 368 C

PANTONE BLACK C

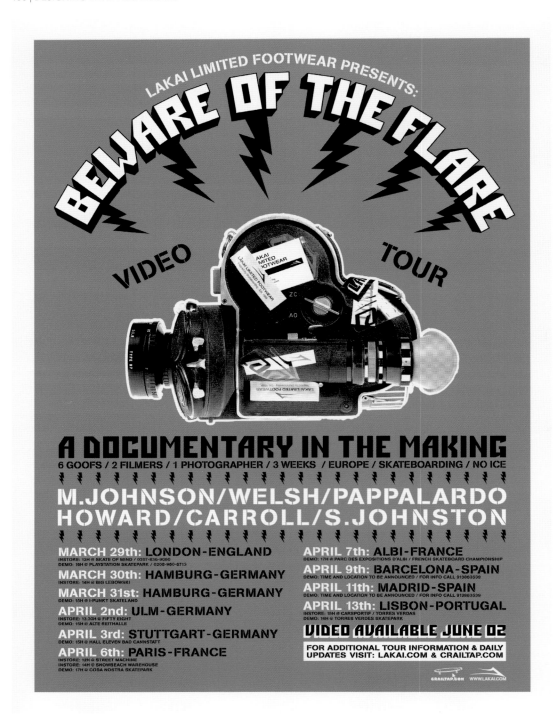

Beware of the Flare Tour ı OhioGirl Design (Andy Mueller). The color green, particularly in its brighter or more acidic hues, is often used in posters associated with pop culture, since it conjures up the idea of freshness and transgression, as in the case of this poster promoting a documentary created by the Lakai brand.

158 orte Schweizer Literaturzeitschrift

Verlegen als Passion

Swiss Independent Publishers SWIPS

Orte Magazin Nr. 158 ı Designalltag Zürich (Ruedi Rüegg). Although the original intention was to use a palette of red and white for this Swiss magazine, the designer finally used green to avoid being accused of an excess of patriotism. The Helvetica New 75 Bold and 65 Medium fonts add a refreshing, modern touch.

PANTONE 368 C

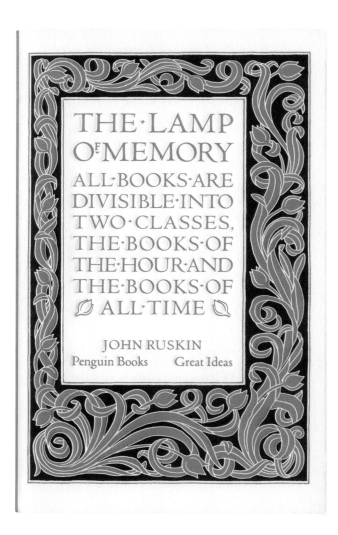

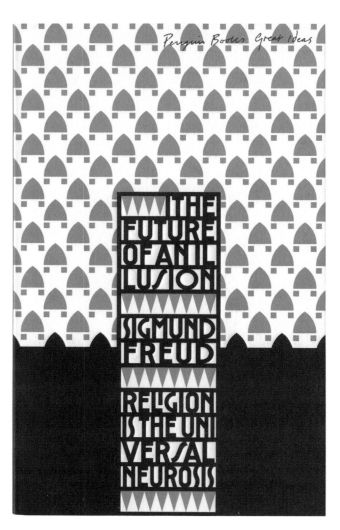

PANTONE BLACK C

Great Ideas Series ı David Pearson. Covers for a series of one hundred books, unified by a limited palette of shades of green. The typeface places each book in its historical and geographical context, while the counter-relief on off-white matte paper imitates the traditional method of printing.

FRIEDRICH·
NIETZSCHE·
MAN·ALONE·
WITH·HIM·

Every superior human being
will instinctively aspire after
a secret citadel where he is
set free from the crowd, the
many, the majority.

SELF

Penguin Books Great Ideas

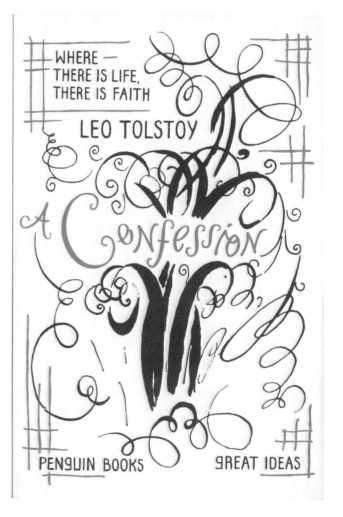

WHERE —
THERE IS LIFE,
THERE IS FAITH

LEO TOLSTOY

A Confession

PENGUIN BOOKS GREAT IDEAS

PANTONE 368 C

PANTONE BLACK C

PANTONE 374 U

PANTONE BLACK 6 U

Fumalab Records No. 04 ı BANK™. Maximum abstraction: a simple wash of dark green for this CD by musician Felipe Valenzuela. Patterns of this type are the hallmark of the Berlin record label Fumalab, and have become its distinguishing feature *par excellence*.

PANTONE 375 C

11 Out
2008 —
28 Fev
2009

ciclo 3R
Reabilitar/Reutilizar/Reciclar
Ciclo de formação sobre
arquitectura e sustentabilidade

Para saber mais…
www.oasrn.org/3R

OA/SRN
Ordem dos
Arquitectos
Secção
Regional
Norte

Temas
Reabilitação Urbana na Óptica da Sustentabilidade
Eficiência Energética nos Edifícios Existentes
Tecnologias de Restauro e Reabilitação
Princípios e Estratégias Bioclimáticas
Uso Racional, Reaproveitamento e Reciclagem de Água
Espaços Exteriores em Centros Urbanos
Tecnologias e Materiais Sustentáveis
Sistemas de Certificação Ambiental

Eventos
Seminários
Workshops
Cursos
Sessões Técnicas

R2 / WWW.R2DESIGN.PT

3R ɪ R2. Design to promote a workshop on architecture and
sustainability organized by the Association of Portuguese
Architects. The color green has been used as a metaphor for
recycling and environmental sustainability.

PANTONE BLACK C

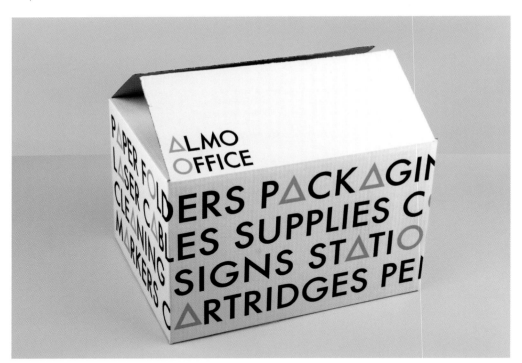

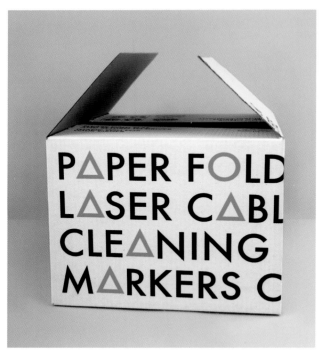

Almo ı Company. Corporate identity developed from the abstraction of the letters "A" and "O," converted into a triangle and a circle, which are precisely the recurring motifs that identify the brand. The colors green and black represent the company's environmental commitment.

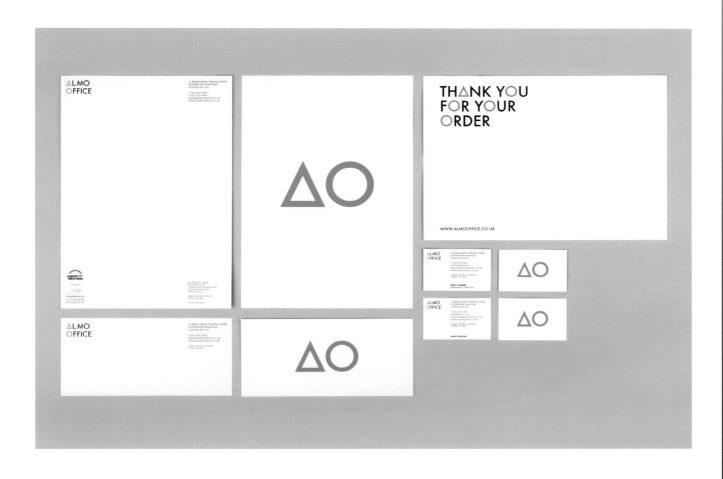

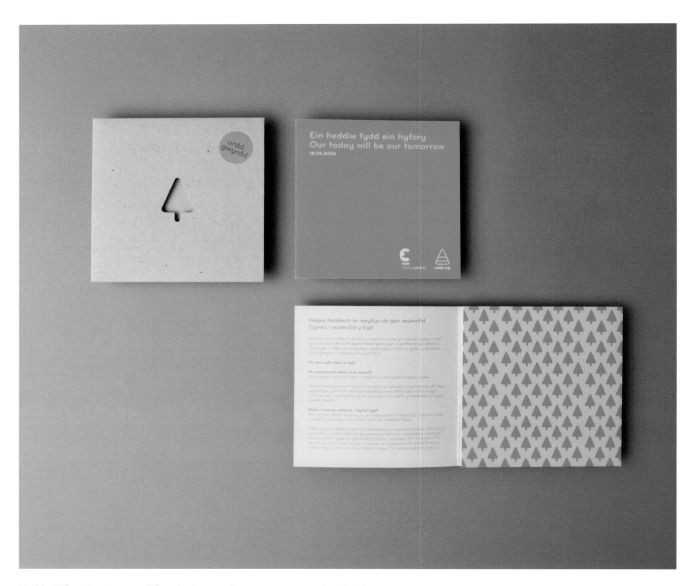

Urdd ı Elfen. Each year, Elfen designs a piece to promote the Urdd
message of peace and goodwill. On this occasion, the subject
was the environment and, with this in mind, a case and leaflet,
in which the predominant color was green, were designed and
printed in recycled materials.

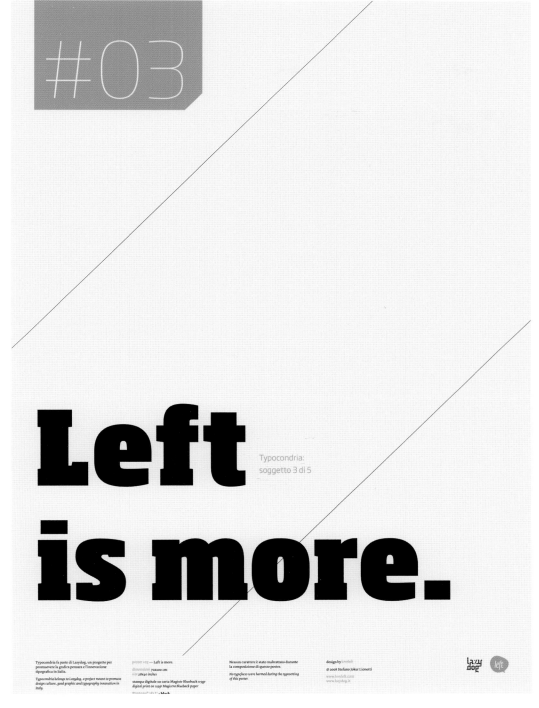

#03

Typocondria:
soggetto 3 di 5

Left
is more.

Typocondria fa parte di Lazydog, un progetto per promuovere la grafica pensata e l'innovazione tipografica in Italia.

Typocondria belongs to Lazydog, a project meant to promote design culture, good graphic and typography innovation in Italy.

poster #03 — Left is more.

dimensioni 70x100 cm
size 28x40 inches

stampa digitale su carta Magistr Blueback 115gr
digital print on 115gr Magistra Blueback paper

Nessun carattere è stato maltrattato durante la composizione di questo poster.

No typefaces were harmed during the typesetting of this poster.

design by loveleft

© 2008 Stefano Joker Lionetti

www.loveleft.com
www.lazydog.it

lazy dog left

Typocondria #03 ı Loveleft. A dash of color, a play on words ("left is more" in contrast to the classic "less is more") and a robust typeface is all this poster needs with respect to typography and design to function visually.

PANTONE 382 C

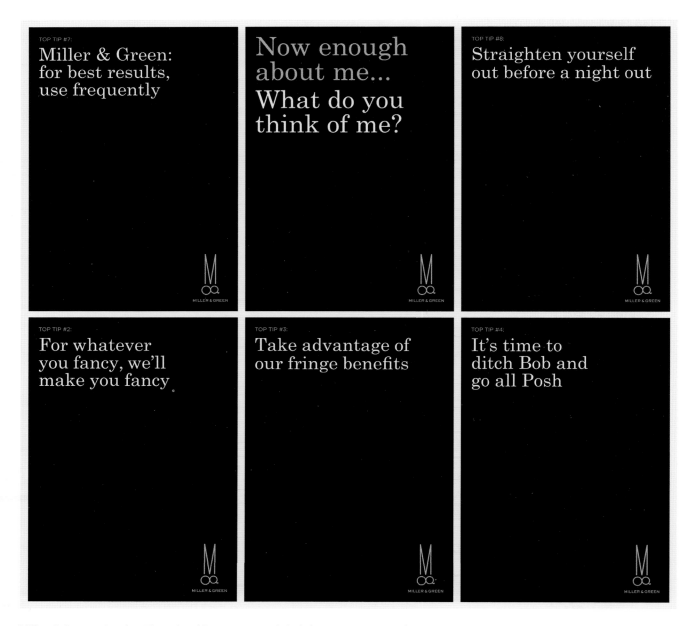

TOP TIP #7:

Miller & Green: for best results, use frequently

Now enough about me... What do you think of me?

TOP TIP #8:

Straighten yourself out before a night out

TOP TIP #2:

For whatever you fancy, we'll make you fancy

TOP TIP #3:

Take advantage of our fringe benefits

TOP TIP #4:

It's time to ditch Bob and go all Posh

Miller & Green I Landor. The mix of lime green and dark brown reflects the elegant, lively ambiance of the Miller & Green hairdressing salon. The logo is made up of the initials of the name of the hairdresser's, arranged and adjusted to look like a pair of scissors.

PANTONE 412 C

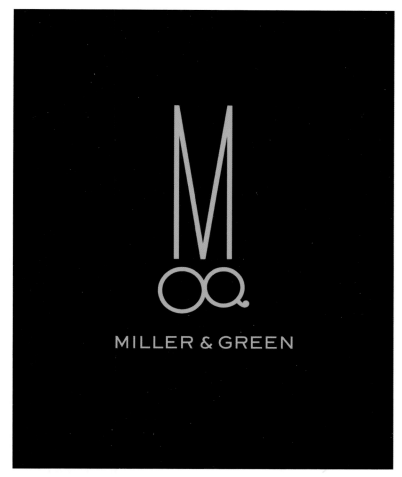

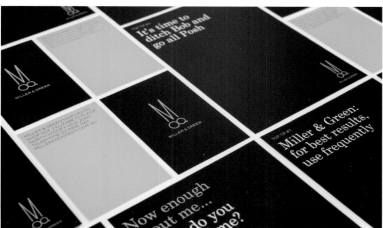

PANTONE 382 C

PANTONE 412 C

PANTONE 583 C

PANTONE 396 C

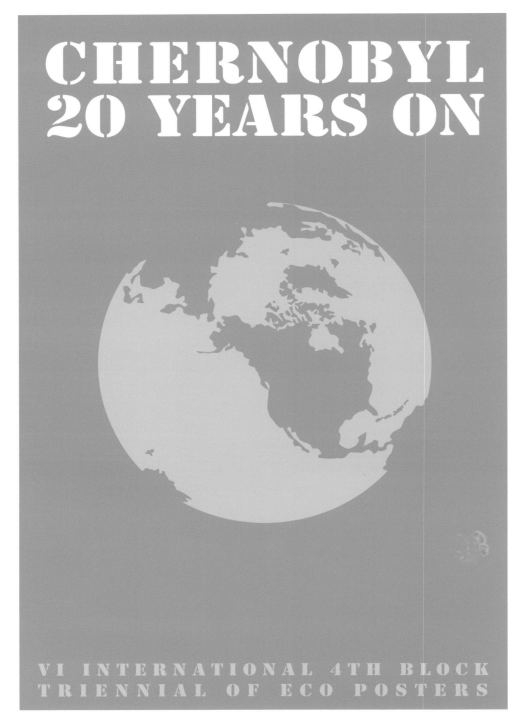

Chernobyl 20 Years On ı Richard B. Doubleday. Poster recalling the accident of the Chernobyl nuclear power station. Here, green is mixed with a shade of yellow to produce a slightly acidic and visually sour combination—color as an environmental metaphor and statement.

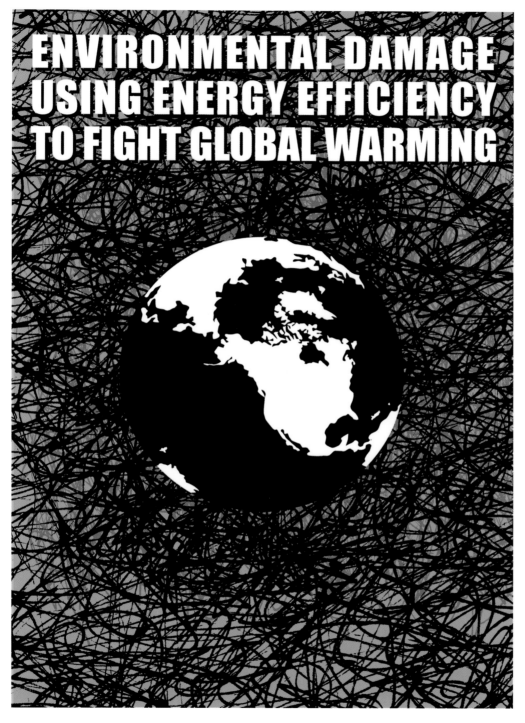

ENVIRONMENTAL DAMAGE USING ENERGY EFFICIENCY TO FIGHT GLOBAL WARMING

Environmental Damage | Richard B. Doubleday. In this poster design, a web of black squiggles and scrawls on a wash of color functions as a metaphor for air pollution and the damage caused by global warming. The shade of green used for the background is associated with ecology and nature.

PANTONE 621 C

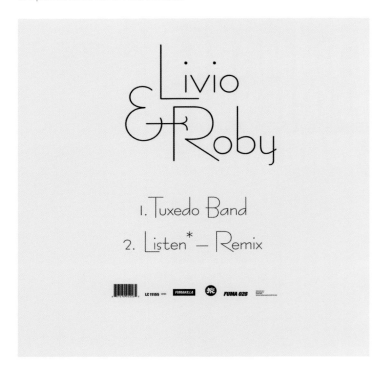

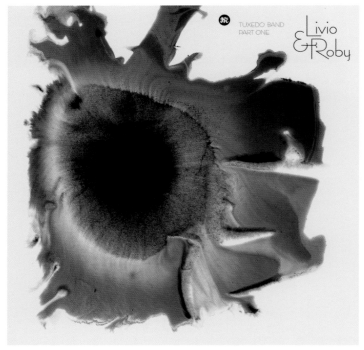

Fumakilla Records No. 28 ı BANK™. For the cover of a single by the Romanian music duo Livio & Roby, the designers utilized pastel shades in an intentionally stark layout to suggest a dreamy, romantic atmosphere.

PANTONE BLACK C

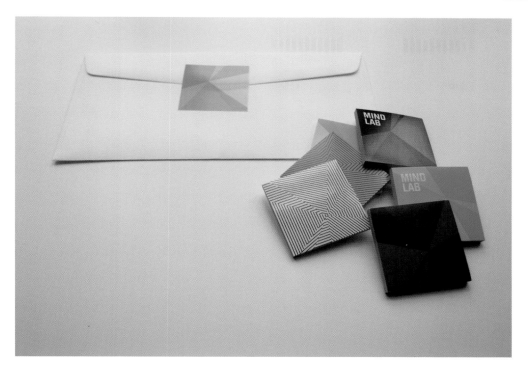

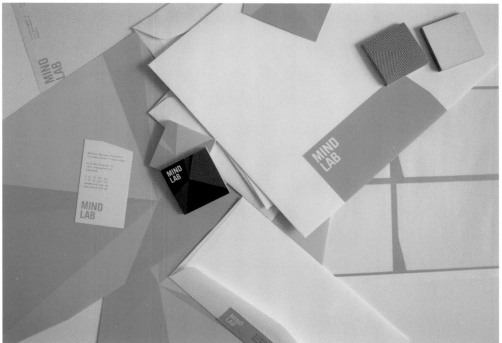

MindLab ı All the Way to Paris. Mindlab is a cross-ministerial department that connects Danish citizens with the government. The metaphorical prism through which we see the world from new and different perspectives causes the light to become more diffused, represented by a color in three different shades of intensity.

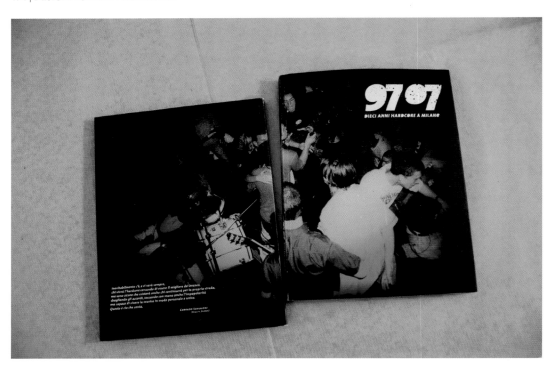

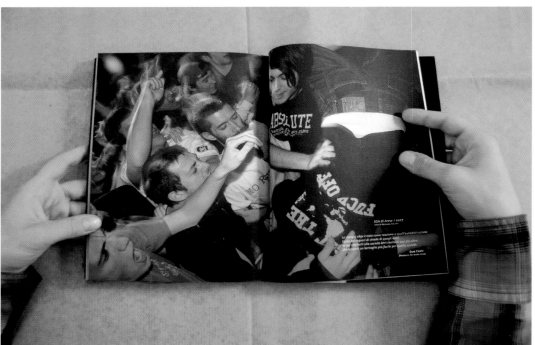

97 07 ı Zetalab. Here is an original and eye-catching effect: Color part of a black-and-white photograph using a bright color (in this case, green) to get a spray-painted effect.

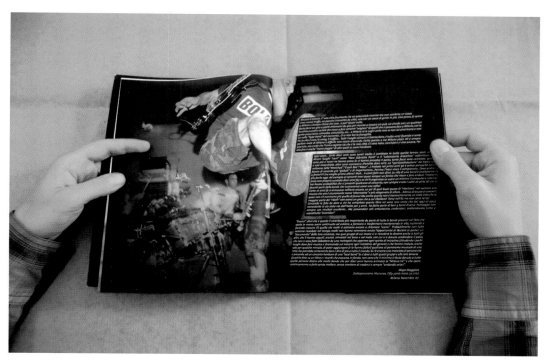

PANTONE 802 C

PANTONE BLACK C

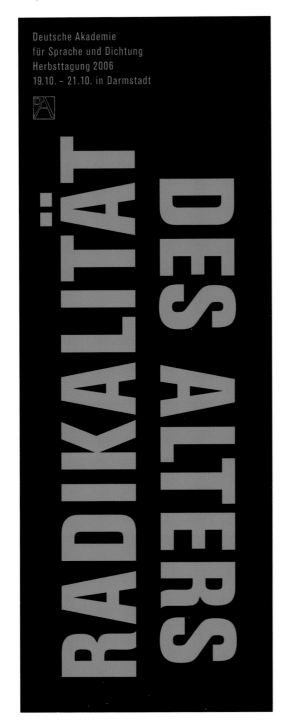

Deutsche Akademie
für Sprache und Dichtung
Herbsttagung 2006
19.10. – 21.10. in Darmstadt

RADIKALITÄT DES ALTERS

Radikalität des Alters ı Rosagelb. This lecture, which can be translated as "the radicalism of age," deals with the subject of the aging population. To attract the viewer's attention, a bold font was used, similar to the one seen in political posters, along with highly contrasting colors.

UN AUFGERÄUMT AS FOUND S AM

As Found ı Claudiabasel. Lacking the possibility of playing with the contrasts that come into being as a result of using more than two colors, one solution, when designing a composition like the one on this page, is to split the workspace in two and keep one purely for the graphic illustration.

PANTONE 802 C

PANTONE BLACK C

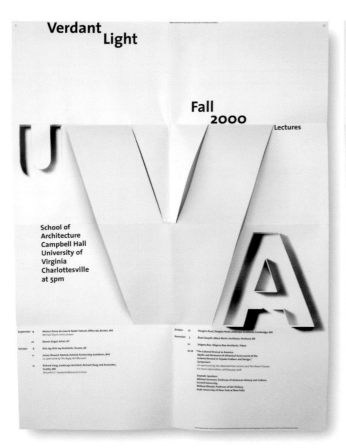

Verdant Light ı StudioWorks (Keith Godard). In this three-dimensional poster for a cycle of lectures by landscape architects, the fluorescent green found on the back of the poster can be glimpsed through openings in both sides of the enormous "V" that presides over the whole design.

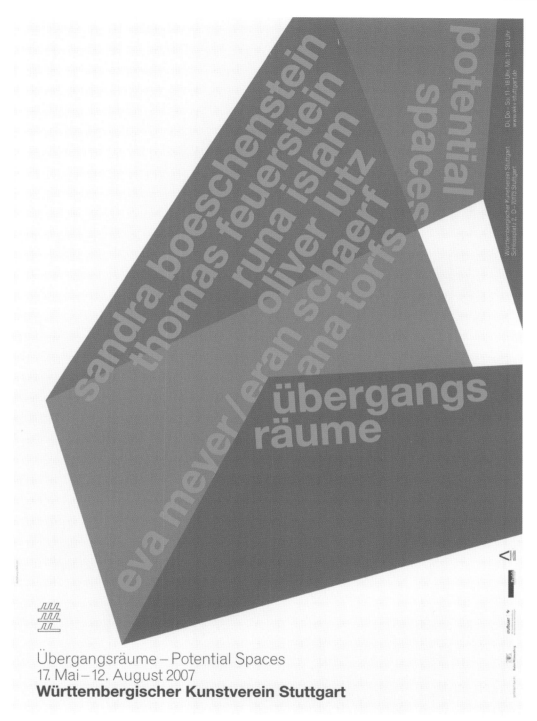

Übergangsräume – Potential Spaces
17. Mai – 12. August 2007
Württembergischer Kunstverein Stuttgart

Potential Spaces ı L2M3 Kommunikationdesign (Ina Bauer, Sascha Lobe). Although this poster, which promotes the collective Übergangsräume exhibition organized by the Württembergischer Kunstverein in Stuttgart, is obviously two-dimensional, the clever use of color and gradient gives the work a three-dimensional feel.

PANTONE 809 C

PANTONE WARM GRAY 9 C

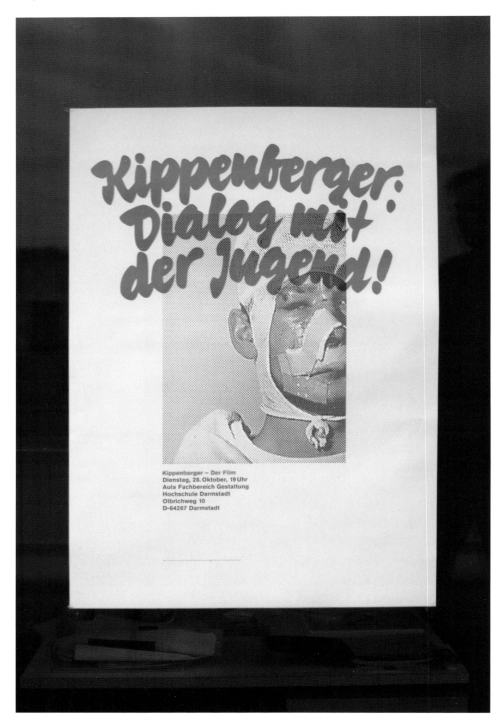

Kippenberger ı Brighten the Corners (Billy Kiosoglou, Frank Philippin).
Poster promoting the movie *Kippenberger* by Jörg Kobel. The image
and text are an adaptation of the work of the artist M. Kippenberger.
The Brush typography, by F. Blankenhorn, brings out the distressing
message of the film.

IN DER WÜSTE DER MODERNE

HAUS DER KULTUREN DER WELT

JOHN-FOSTER-DULLES-ALLEE 10
10557 BERLIN | FON 030-39787175

WWW.HKW.DE

KOLONIALE PLANUNG UND DANACH
29.8. – 26.10.08

AUSSTELLUNG, FILM
PERFORMANCE, GESPRÄCHE
INTERNATIONALE KONFERENZ

AUSSTELLUNG
Di – So + feiertags 12 – 20 h,
Do bis 22 h

In der Wüste der Moderne ı Double Standards. In this design for
a multidisciplinary exhibition on colonialism, the varying degrees
of intensity in the color refer to the basic idea forming the crux
of the exhibition and play with the feeling of depth and three-
dimensionality, mimicking the shadows of the real world.

Instant Urbanism ꟾ Claudiabasel. In this poster, promoting a group exhibition on situationism and architecture, the different letters are arranged in ascending order of size, giving the design a sense of depth. The additional color gradient enhances the design's three-dimensional feel.

PANTONE 9060 C

PANTONE 877 C

Zeichnungen Reinhold Adt, Iris Alvarenga, Holger Appenzeller, Barbara Armbruster, Sabina Aurich, Elke Bach, Max Gerhard Bailly, Cristina Barroso, Rosa Baum, Agathe Baumann, Sigrid Baumann-Senn, Beate Baumgärtner, Margarete Baur, Sibylle Beck, Rik Beck, Gabriele Beitelhoff-Zeger, Ea Bertrams, Tatjana Bien, Dagmar Binanzer-Kraus, Beate Bitterwolf, Elisabeth Blank, Friedemann Blum, Sieglinde Bölz, Aquilina Boes, Renate Bogatke, Karl-Heinz Bogner, Bea Bolesch, Eva Borsdorf, Ulrike Brennscheidt, Sibylle Burrer, Michael Danner, Marion Delsor, Hans Martin Dieterich, Anita Dietrich, Klaus Dietrich, Elin Doka, Christa Düwell, Gerald Dufey, Ingrid Eberspächer, Martin-Ulrich Ehret, Salah El-Asser, Gert Elsner, Ubbo Enninga, Hildegard Esslinger, Susanne Feix, Barbara Fernandes, Dagmar Feuerstein, Iris Flexer, Evelyne Foraboschi, Andreas Franz, Gudrun Freder, Gerhard Friebe, Volker Frommann, Angela Garry, Martina Geiger-Gerlach, Carola Gera-Staber, Birgit Gessner, Gisel, Christine Gläser, Gertrud Gläser, Gotthard Glitsch, Ilka Götz, Doris Graf, Niko Grindler, Lene Rose Gruner, Anna Hafner, Rupert Hagn, Ingrid Hartlieb, Hattiriel, Rolf Hausberg, Thomas Heger, Tim-Stefan Heger, Titus Helmke, Vanessa Henn, Sigrid Anne Herold, Ernst Günter Herrmann, Kathrin Hinderer, Helga Hodum, Silvia Hörner, Margarethe Hoffmann, Rotraud Hofmann, Michael Hofmann, Eva Hoppert, Harald Huss, Susanne Immer, Su-Grobholz In-Soon, Gisela Jäckle, Ingolf Jännsch, Andreas Jauss, Ulrich Jerrentrup, Carolin Jörg, Iris Juerges, Jang-young Jung, Barbara Karsch-Chaieb, Sybille Kaschluhn, Helga Kellerer, Katrin Kinsler, Izumi Kobayashi, Eberhard Krämer, Lothar Krakowczyk, Heidi Kucher, Klaus Kugler, Joachim Kupke, Melanie Lachieze-Rey, Joachim Lambrecht, Elke Lang-Müller, Friedrich Laubengeiger, Helmut Laun, Won Ho Lee, Yang-Hee Lim, Gregor Linz, Anja Luithle, Jörg Mandernach, Denise Mandernach, Leni Marx, Marijo Matic, Susanne Maute, Frank Mezger, Maike Mezger, Frank Mrowka, Johannes Daniel Münch, Heidemarie Mungenast, Julia Münz, Bodo Nassal, Ingeborg Neef, Dorothee Nestel, Gi Neuert, Wolfgang Neufang, Norbert Nolte, Monika Nuber, Thea Obergfell, Hartmut Ohmenhäuser, Andreas Opiolka, Anna Ottmann, Georg Ozory, Vito Pace, Silke Panknin, Sangho Park, Ingeborg Parma-Block, Lidija Paunovic, Andrea Peter, Brigitte Pfaffenberger, Hans Pfrommer, Marlene Philippin, Stephan Potengowski, Martin Rauch, Johannes Rave, Christina Redenbacher, Regine E, Ursula Reichart, Siggi Reiche, Günter Reichenbach, Stefanie Reling, Regine Richter, Anne Rinn, Irmgard Röhrle, Sylvia Rösch-Jarosch, Annette Rothfuss, Tobias Ruppert, Maria Grazia Sacchitelli, Klaus Sachs, Monika Schaber, Uwe Schäfer, Rüdiger Scheiffele, Nicole Scheller, Hermann Schenkel, Katharina Schick, Ruth Maria Schleeh, Sigrun C. Schleheck, Frauke Schlitz, Edgar Schmandt, Martin Schmid, Miriam Schmidt-Wetzel, Ina Schneider, Clemens Schneider, Renate Schöck, Cosima Schuba, Ingrid Schütz, Helga Schuhmacher, Heinz Schultz-Koernig, Dorothea Schulz, Martin Schwarz, Ulrich Seibt, Petry Seidel, Norbert Seiler, Ulrich Seutter, Abi Shek, Stef Stagel, Martina Staudenmayer, Anita Stöhr-Weber, Renate Strauß, Sonja Streng, Wildis Streng, Sabine Strobel, Katrin Ströbel, Ha Tae-Bum, Heike ten Brink, Laurenz Theinert, Claudia Thorban, Angelika Timm, Manuela Tirler, Guenther Titz, Hannes Trüjen, Stefan Tümpel, Jutta Uhde, Marinus van Aalst, Thomas Volkwein, Karl Vollmer, Heidemarie von Wedel, Bernhard Walz, Thomas Weber, Marlis Weber-Raudenbusch, Beate Wehr, Veronika Weigel, Martina Weik, Uta Weik, Waltraud Wellmann, Julia Wenz, G. Angelika Wetzel, Gert Wiedmaier, Irmhilt Wolf, Jürgen Zeller, Gabriele Zeller-Kramer, Toni-Andrea Zelter, Danielle Zimmermann, Arnhild Züfle, Andrea Zug

Di, Do – So: 11–18 Uhr, Mi: 11–20 Uhr
www.wkv-stuttgart.de

Württembergischer Kunstverein Stuttgart
Schlossplatz 2, D–70173 Stuttgart

Ausstellung der Künstlermitglieder 2006
17. November 2006 – 7. Januar 2007
Württembergischer Kunstverein Stuttgart

Ausstellung der Künstlermitglieder 2006 ı L2M3 Kommunikationdesign (Ina Bauer, Sascha Lobe, Tessy Ruppert). In keeping with the theme of the exhibition (on "drawings") being promoted, this entire poster (including the logos of the sponsors), designed for the Württembergischer Kunstverein in Stuttgart, was drawn in pencil. The color was added later during the offset printing process.

Jakarta Good Food Guide ı LéBoYé. Despite the fact that this low-budget project has been printed in two inks on low-quality paper, it is absolutely exquisite. The two shades of color used create a texture that is rich in detail due to the application of various swathes of color.

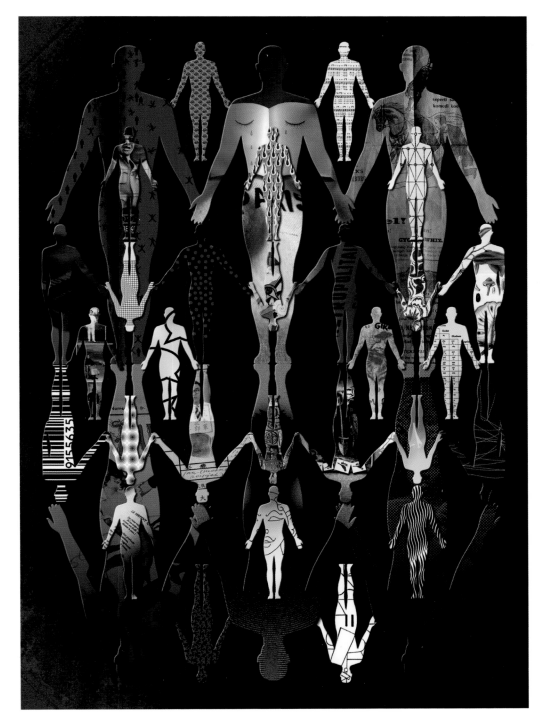

Noir sur Noir ı LéBoYé. In this poster for a visual arts exhibition, the designer has played with the basic elements of shading and various layers to achieve a novel effect. Two black inks were used in the design, along with gradients to which extra black was added.

PANTONE COOL GRAY 2 C

PANTONE BLACK C

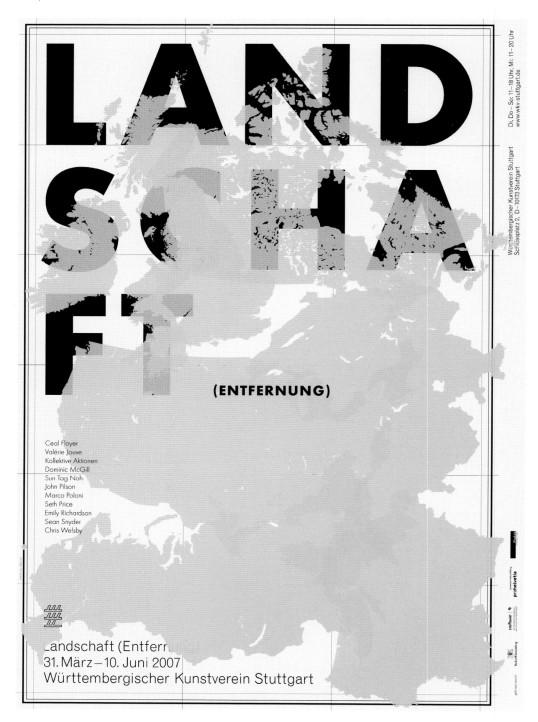

Landschaft ı L2M3 Kommunikationdesign. This poster promoting
an art exhibition visually represents the underlying concept
(landscape and distance) through a composition based on the
overlap of the lettering and an abstract wash of color. The link
between the poster and the theme of the exhibition tries to be
more emotional than rational.

154 orte Schweizer
Literaturzeitschrift

Die besten Gedichte aus dem Lyrik-Wettbewerb 2007

Orte Magazin Nr. 154 ı Designalltag Zürich (Ruedi Rüegg).
The white background and handwritten text, in the manner
of an illustration, offers a literary style for this cover for *Orte*
magazine, dedicated to the best poems submitted for
a competition organized by the magazine.

PANTONE COOL GRAY 3 C

PANTONE BLACK C

PANTONE 877 U

PANTONE BLACK U

Hiltl Monatsprogramm November/Dezember 2009 I Atelier
Bubentraum (Anton Studer). Posters for the meetings during the
months of November and December in 2009 held by the Hiltl Club
in Zurich, which houses one of the oldest vegetarian restaurants
in the city. The limited color palettes help unify the design on a
visual level.

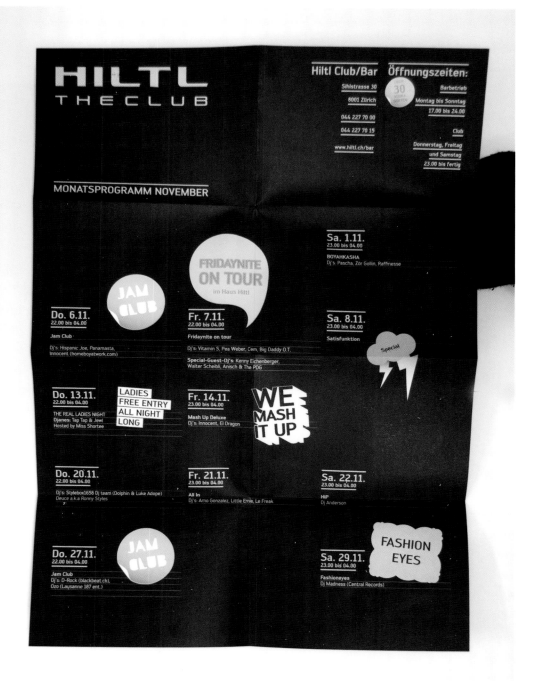

PANTONE 877 C

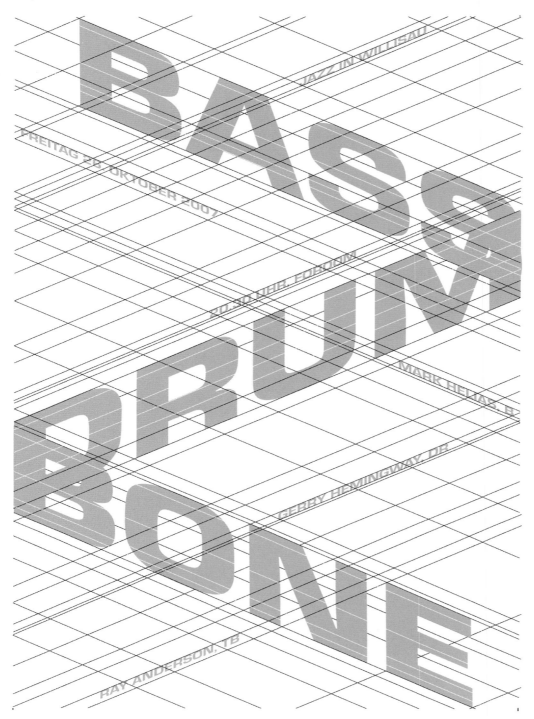

Bass Drum Bone ∎ Niklaus Troxler. In this poster for a jazz concert, the layout of the texts and kinetic lines creates a grid, making the design appear to be three-dimensional. The color of the fonts enhances the effect of spatial depth.

PANTONE BLACK C

10. INTERNATIONALER PLAKAT KUNST HOF RÜTTENSCHEID PREIS 2007 AN ISTVAN OROSZ, BUDAPEST

AUSSTELLUNG IM GRILLO THEATER ESSEN

VOM 14. SEPTEMBER 2007 BIS 6. JANUAR 2008

GEFÖRDERT DURCH
DEUTSCHES PLAKAT MUSEUM ESSEN
PLAKAT KUNST HOF RÜTTENSCHEID

PLAKAT: NIKLAUS TROXLER

István Orosz � Niklaus Troxler. The vertical and horizontal bands in the center of this poster create an image that has an op art effect. The information was printed using a typeface that simulates lettering drawn with a stencil.

PANTONE 5435 C

PANTONE BLACK C

2C

1C

DUAL CITY SESSIONS 2008

art
with
sound ™

DMY Berlin
21-25 May 2008
International Design Festival
Berlin 2008

JAPAN

artless + noiselessly
Adapter + The Samos
Merry™ + Leo Sato
Raku-gaki + Soothe
Tycoon Graphics + Merce Death

SINGAPORE

4femmes + Fugu.san
Djohan + Fezz
Phunk Studio + Victor Low (The Observatory)
SILNT + MUON
Steve Lawler + AntiGravityChocolate

Curation
artless (Japan) and **SILNT** (Singapore)

Exhibition design
upsetters architects

DUAL CITY SESSIONS 2008 **art with sound™** **artwork by** **calligraphy by**
tradition with modernity Shun Kawakami (artless) Gen Miyamura

Japan.

Art with Sound ı Artless. The calligraphy-like illustration by
artist Shun Kawakami is the most prominent element in this
poster and immediately demands the viwer's attention. With its
monochromatic look, it is a statement on the duality of tradition
and modernity.

Zoo ı Underline Studio. This is both a promotional poster for
Zoo, an electronic art exhibition, and an information leaflet on
the InterAccess Gallery. Working with a very tight budget, the
designers decided to print the logo in a single color on white paper.

THE RIGHT TO FREEDOM FROM PERSE-CUTION

THE RIGHT TO FREE THOUGHT & CON-SCIENCE

THE RIGHT TO FREEDOM OF MOVEME-NT

THE RIGHT TO REBELLION AGAINST TYR-ANNY

The Universal Declaration ı The Luxury of Protest. A pattern of dots forms the main pivot in these posters in honor of the Universal Declaration of Human Rights. The black circles express the essence of each article in the Declaration by way of contrast with a dot that appears to have been drawn by hand.

2 Dots ı The Luxury of Protest. These two posters, designed for the war museums in Nagasaki and Hiroshima, commemorate the sixty-first anniversary of the nuclear attacks. The minimalist design and the use of a single, stark color were intentionally meant to reflect the horrific nature of the commemorated events.

The Watch Man ı Underline Studio. This poster, which promotes
the video and sound exhibition by artist Shona Illingworth at the
InterAccess Gallery, resorts to a monochromatic design of black
on a white base, and simulates the effect of a distorted lens.

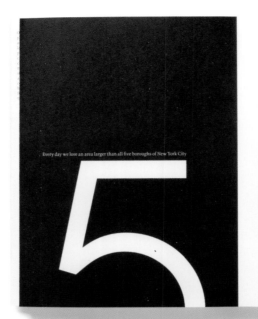

Every day we lose an area larger than all five boroughs of New York City

At this Rate ı Studio8 Design. The addition of bright colors to an abstract illustration, such as the one seen here on a leaflet for the environmental organization San Francisco Rainforest Action Network, would only create visual confusion. The use of black on a white background brings visual clarity and relaxation.

Exposición en el CCCB
Del 12 de abril al 1 de mayo

Somalia: sobrevivir al olvido
Una exposición de Médicos Sin Fronteras
Fotografías de Pep Bonet

Exposición en el CCCB
Del 12 de abril al 1 de mayo

Somalia: sobrevivir al olvido
Una exposición de Médicos Sin Fronteras
Fotografías de Pep Bonet

Somalia ı Estudio Diego Feijóo. For the poster of this exhibition for the NGO Doctors without Borders, which attempts to denounce the suffering of the Somali people, iconic images (a fence, bullet holes, etc.) were used in high-contrast, high-impact black-on-white backgrounds.

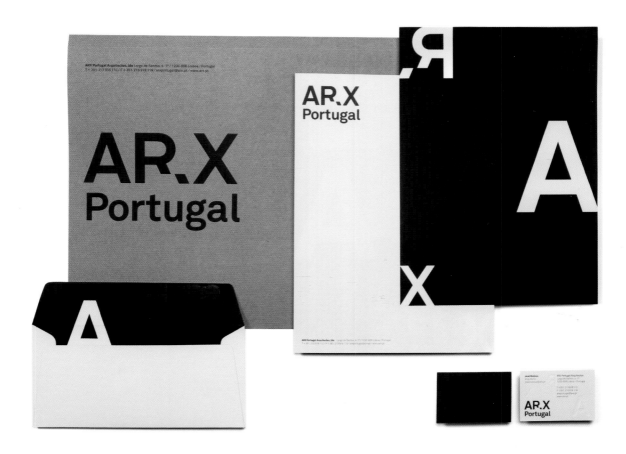

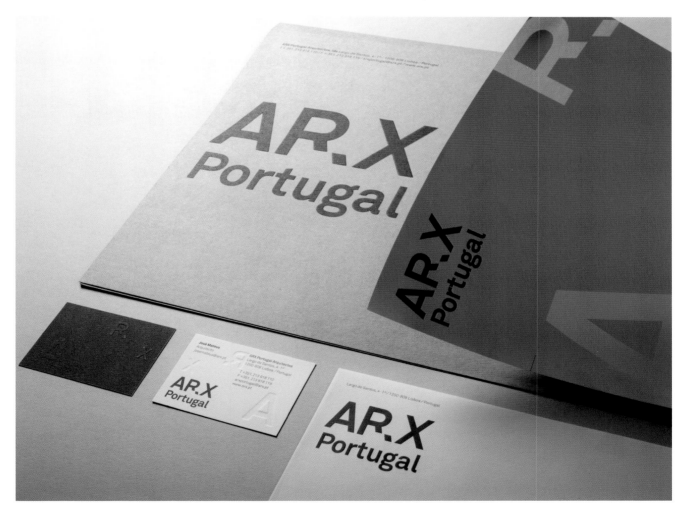

ARX ı R2. The arrangement of the printed letters on paper of
varying texture and color in this piece of stationery invites the
viewer to explore its empty spaces. The typeface used is Akkurat,
designed by Laurenz Brunner.

BREATHE

Forests are the lungs of the earth. The destruction of forests has been a fortifying factor in climate change. With millions of miles of old growth forests cleared every year, the earth is slowly suffocating under the increase of greenhouse gases.
www.ran.org

Breathe ı Studio8 Design. Trees drawn in the shape of human lungs illustrates the main message of this poster—"Breathe"—for the Rainforest Action Network. The use of the color black is intentional and is meant to illustrate pollution.

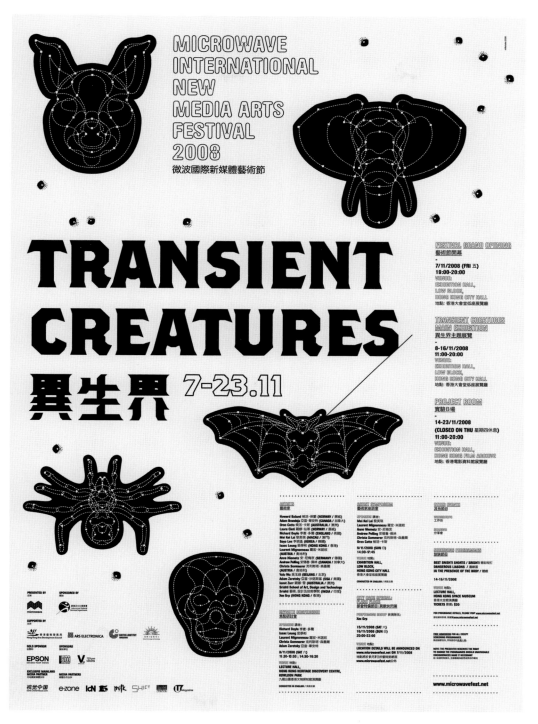

Microwave International New Media Arts Festival 2008 ı
Milkxhake. Twelve illustrated black-and-white figures and
creatures were designed for the Microwave International New
Media Arts Festival. These figures and creatures were used on
the festival's promotional materials, such as posters, stickers,
and graphics, and symbolized the notion of transience.

Individual Utopias ı Laboratorium. This is a catalog on an artistic project that reflects on the role of art in healing the mentally ill in Bosnia. The crate, illustrated with nameless portraits and the administrative stamp in purple, indicates closed cases of anonymous victims of the war in Bosnia.

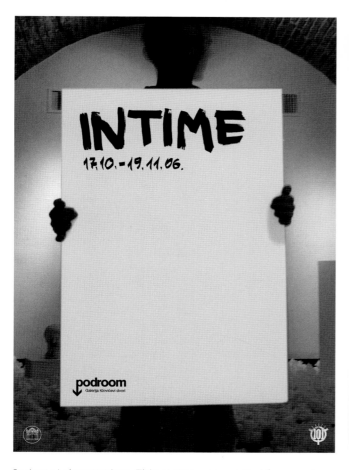
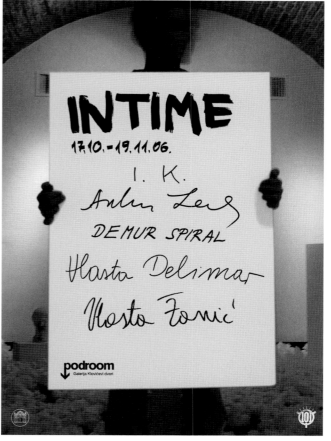

Intime ı Laboratorium. This poster was created for an art exhibition that centered on the exploration of perception, both in terms of how the artists view themselves and the way society sees them, too. The artists' names are written in freehand, which further reinforces the exhibition's underlying concept.

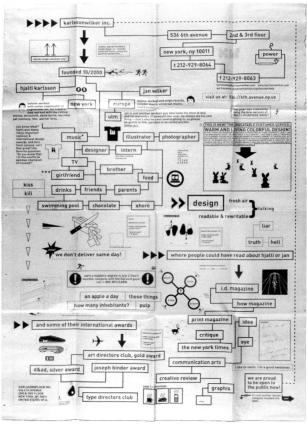

Karlssonwilker Mailer ı Karlssonwilker. The designers
at Karlssonwilker enjoy doing this type of picture with black-
and-white graphics, which allows them to indulge in two of their
hobbies: designing and writing. Their designs are used to self-
promote as well as to surprise and entertain the viewer.

Landjäger ı Christof Nardin. *Landjäger* is a non-periodical publication. Both the magazine and the posters promoting it are produced only in black. The typeface used for all items of the project is Bueronardin, designed by Christof Nardin.

Mudd Club Berlin ı BANK™. Designed from some very strict rules proposed by the client referring to the use of color and the application of the principles of composition, this series of flyers for a club in Berlin resorts to a single-color design in black on white paper.

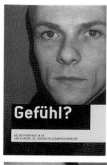
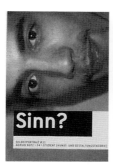
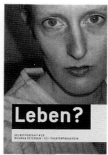
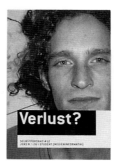
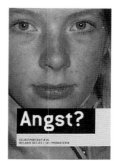

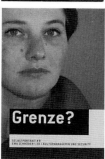

Max Peschek Bodypsychotherapy ı BANK™. This is the corporate design for a psychotherapy clinic. Here, the designers used a single-color composition in black on white paper with the aim of evoking feelings of self-reliance and confidence, while, at the same time, imbuing it with a dramatic quality. The subjects took their own photos.

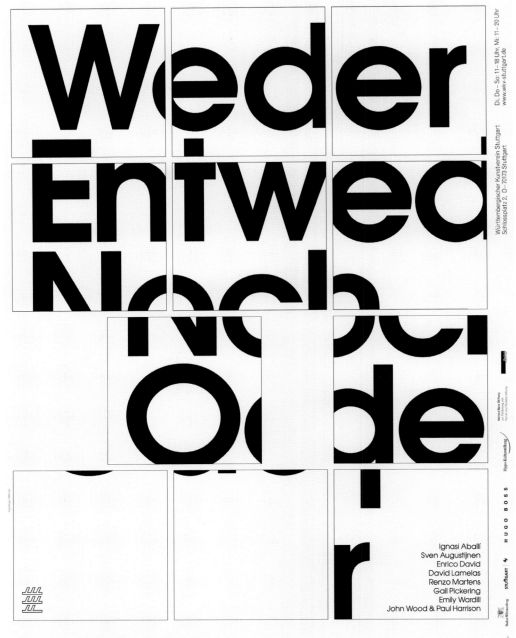

Weder Entweder Noch Oder
31. Mai – 3. August 2008
Württembergischer Kunstverein Stuttgart

Weder Entweder Noch Oder ׀ L2M3 Kommunikationdesign
(Ina Bauer, Sascha Lobe). In this project, the aim was to heighten
the confusion between the concepts associated with the group
exhibition, which was promoted using a single-color font. The
exhibition seems to have shifted and appears in a deconstructed
form just like a jigsaw puzzle.

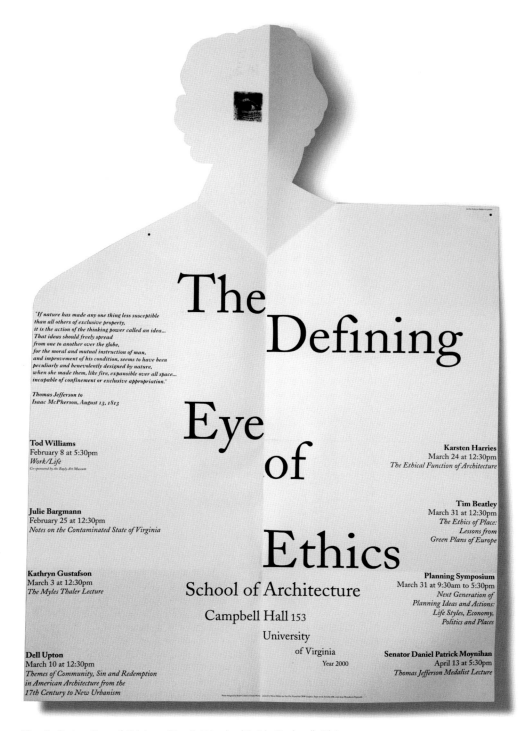

The Defining Eye of Ethics ı StudioWorks (Keith Godard). This poster is designed for a series of lectures on architecture. The designers perforated and folded the paper to achieve a three-dimensional effect, and went with a one-color design as a means to augment the expense of using heavy paper and the labor-intensive costs associated with perforating the paper.

ISSEY MIYAKE INC.

www.isseymiyake.com

1-12-10 Tomigaya,
Shibuya-ku,
Tokyo 151-8554 Japan

Issey Miyake shipping box & poster ı Artless. By dispensing with color and any extra features, the strokes used to draw the letters in the web address for Issey Miyake—printed both on this box and on the poster on the following page—become the design's strongest visual element.

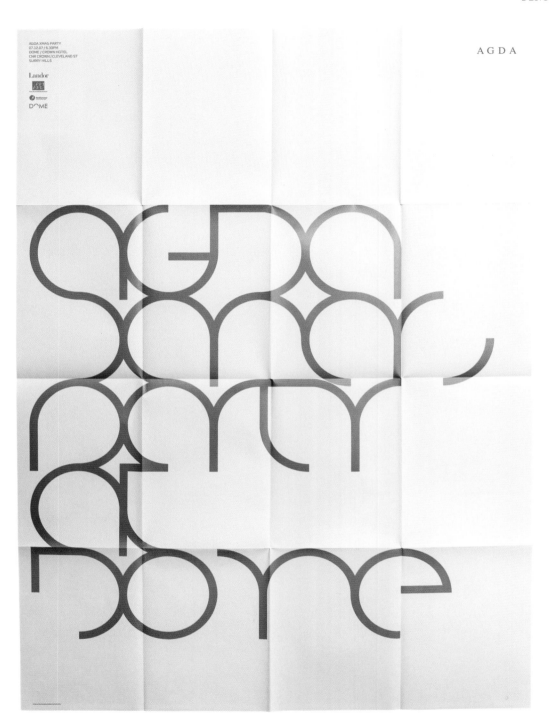

AGDA Xmas ı Landor. The font, designed specifically for this invitation to a Christmas party given by the Australian Graphic Design Association (AGDA), plus the use of metallic ink, reflect the spirit of the celebrations. The large-format poster also commemorates the larger-than-life nature of the festivities.

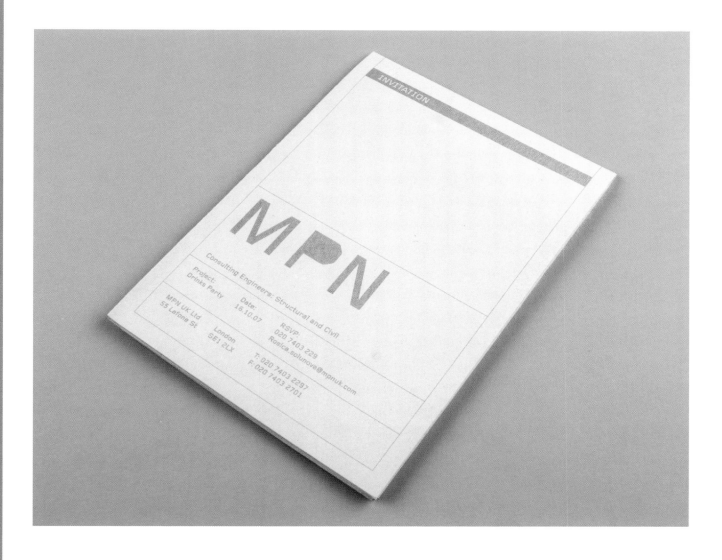

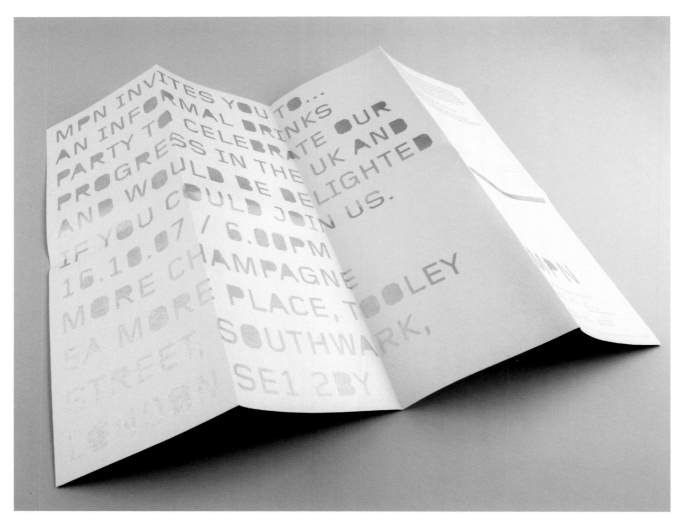

MPN ı Company. For this invitation, designed for an engineering consultancy, a cream-colored card was used. It was folded in the shape of an architectural plan with the typeface printed in silver ink. Some letters are drawn with positive counters to convey the idea of strength and confidence.

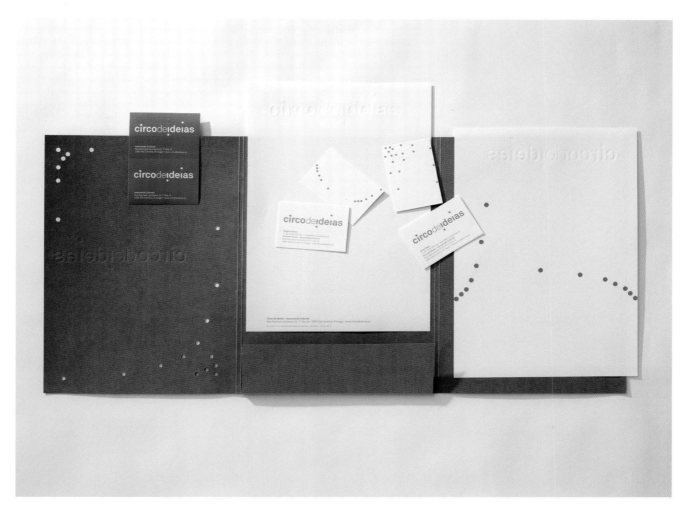

Circo de Ideias ı R2. Using the spatial proportions deriving from the Fibonacci sequence, this logo facilitates the integration of elements associated with the circus and juggling. The limited use of color makes it possible to then proceed to play with the perforation process without swamping the design.

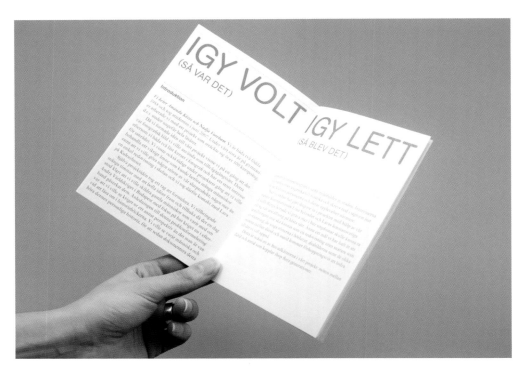

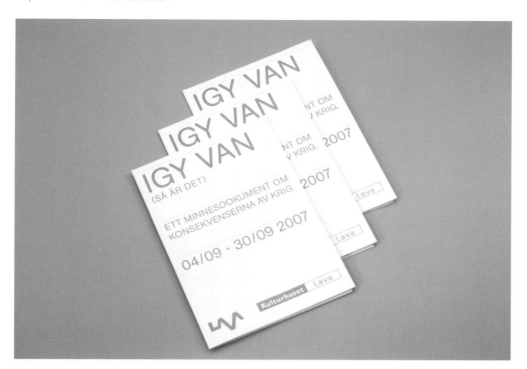

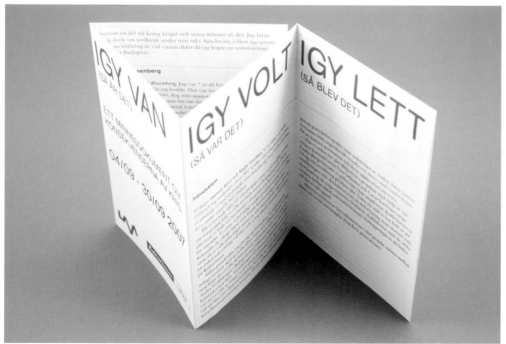

Pocket Sized Memories ı Transfer Studio. Transfer Studio's minimalist and simply structured design arrangement for this exhibition catalog requires a discreet use of color. The result is at once sober and elegant, and mirrors Selander's work.

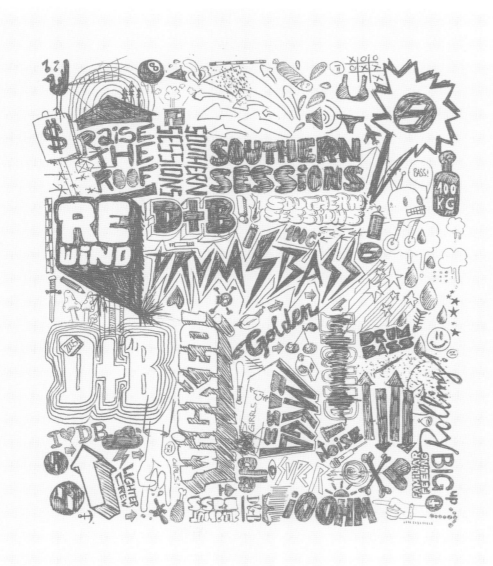

Southern Sessions flyer 02 | C100 Purple Haze. Breaking with the notion that the drum and bass music genre should forever be associated with dark designs and industrial graphic elements, C100 Purple Haze designed the graphic image of Southern Sessions playing together, using a plain color and freehand typographies.

Mater ı All the Way to Paris. This design of All the Way to Paris for Mater, the Danish accessory brand for the home, violates the dogmas of "green" design in its application of a pale, informal shade of color for a supposedly green and sustainable object. The gold embossments contrast with the white matte paper.

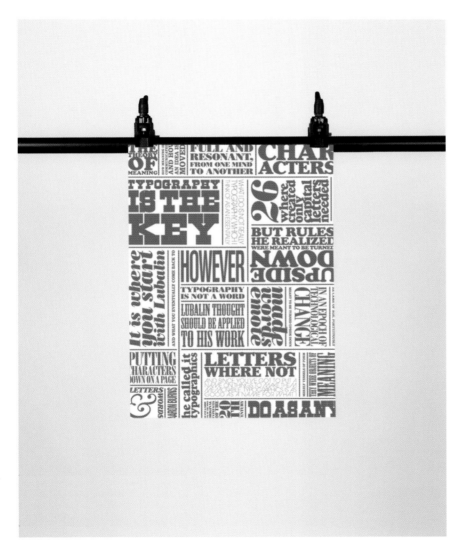

Herb Lubalin ı Magdalena Czarnecki. This book, which pays tribute to the work of graphic designer and typographer Herb Lubalin, utilizes several different typefaces, all arranged in a baroque composition with very little blank space. The elaborate font treatment meant that it was extremely important not to overdo the color. For these reasons, the designers used one color to unify the overall design.

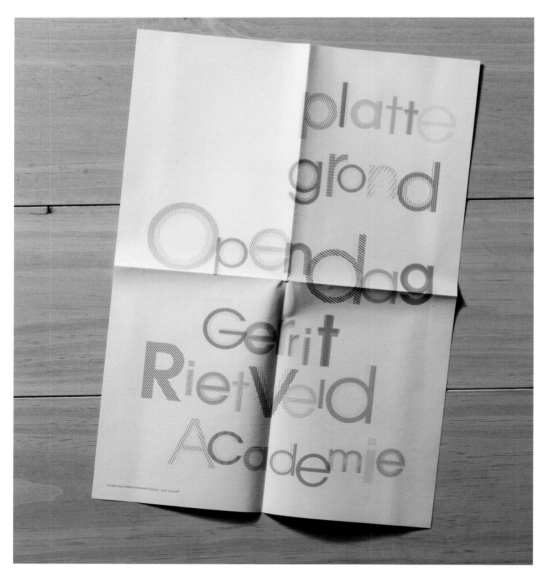

Gerrit Rietveld Academy ı Ingeborg Scheffers, Marriëlle Frederiks
(Gulden Bodem). Thanks to the thickness and varying distance
between the strokes making up the letters in this poster, the
viewer seems to be looking at several different colors instead
of just one shade of green. This gives it the poster a three-
dimensional effect and sense of depth.

Eden Forum ı Touch. Thanks to the thickness and varying distance between the letter strokes, the viewer gets the sensation that he is looking at several different colors instead of just one shade of green. This gives the poster a three-dimensional effect and sense of depth.

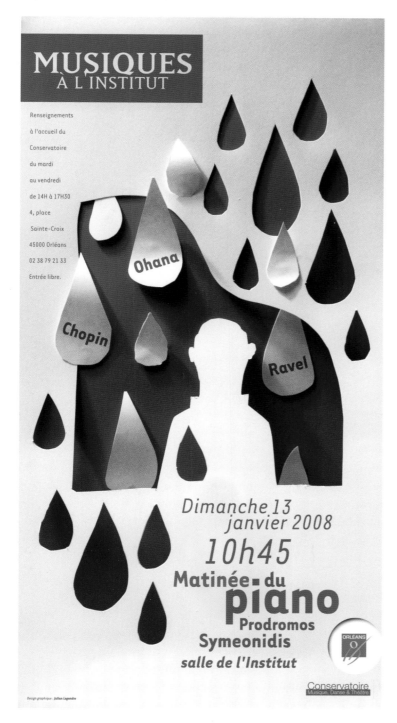

Prodromos ı Atelier Julian Legendre. Poster from the award-winning series designed by Julian Legendre. Color, which varies from poster to poster, is paradoxically the element that provides a visual link for the whole series.

Trans Am Future World CD ı OhioGirl Design (Andy Mueller). The mechanical-sounding music of U.S. band Trans Am is reflected in this cover tinged with retro-futuristic elements reminiscent of the 1980s, thanks to its pixelated style and the use of a greenish tone similar to the era's original green PC screens.

Flanke Kopfball TOR

etc. u. a. u. a.m. u. ä. usf. usw. u. v. a. u. v. m.

Fußball EM 2008
Aula Fachbereich Gestaltung
Hochschule Darmstadt

Rumänien vs. Frankreich
9. Juni / 18:00

Niederlande vs. Italien
9. Juni / 20:45

Spanien vs. Russland
10. Juni / 18:00

Griechenland vs. Schweden
10. Juni / 20:45

Österreich vs. Deutschland
16. Juni / 20:45

Frankreich vs. Italien
17. Juni / 20:45

Flanke, Kopfball, Tor ı Brighten the Corners (Billy Kiosoglou, Frank Philippin). This allegorical poster was designed for the University of Applied Science in Darmstadt on the occasion of Euro Cup 2008. For their minimalist design, a simple monochrome text was applied in green without the addition of any graphic motifs or ornamentation whatsoever.

PANTONE 2925 U

Charhizma Records ı BANK™. Color is often used as a design strategy to replace other sorts of elements of a more expressive nature. In this work, the Charhizma Records label has opted for a neutral blue to represent abstract images, associated with repeated musical patterns.

PANTONE 2736 C

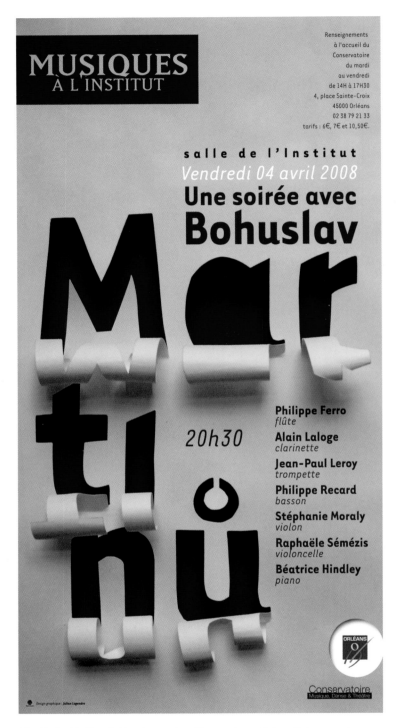

Martinü ı Atelier Julian Legendre. The various tints of blue used here reinforces the sense of depth provided by the letters, which are cut in the style of the templates used by street artists.

PANTONE 279 C

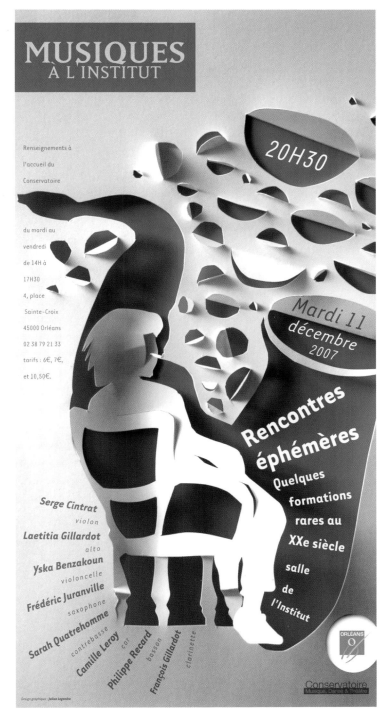

Éphémère ı Atelier Julian Legendre. This poster for a concert invites the viewer to discover the main points of the information by "lifting" the tabs cut out in the paper. The color blue was chosen for its capacity to symbolically represent the sinuous meanderings of music.

Helvetica ı Brighten the Corners (Billy Kiosoglou, Frank Philippin).
The poster of the documentary *Helvetica*, directed by Gary
Hustwit, consists of a list of famous typographic fonts drawn up
in alphabetical order using the Helvetica font, with some of the
letters missing from the names.

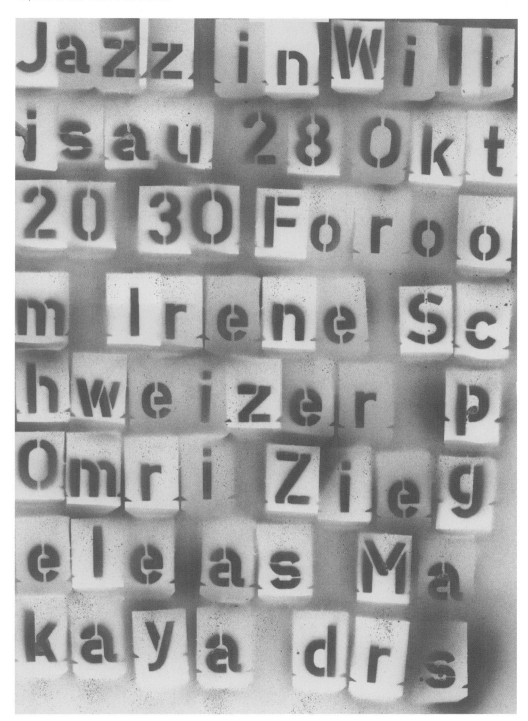

Irène Schweizer ı Niklaus Troxler. This poster announces a concert
by the Swiss jazz pianist Irène Schweizer and has been put
together in the form of a collage, using templates of red painted
letters and numbers that look as if they had been sprayed on.

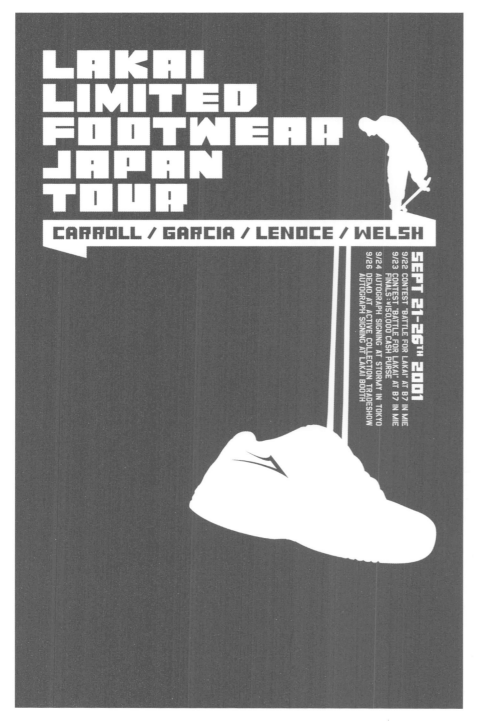

Lakai Limited Footwear Japan Tour ı OhioGirl Design (Andy Mueller).
This poster was designed for the Lakai brand of trainers. The color
combination of magenta and white creates a balanced sense of
color and conveys the feeling of youthful freshness, which in turn
reinforces the relaxing effect of the poster.

PANTONE 226 C

Deutsche Akademie
für Sprache und Dichtung
Forårsmøde 2006
11.05. – 13.05. i København

Dänemark

Tyskland

Dichterfest/Digterfest 11. maj 2006

Inger Christensen Herta Müller
Durs Grünbein Oskar Pastior
Pia Juul Robert Schindel
Peter Laugesen Pia Tafdrup

Tyskland-Dänemark ı Rosagelb. The poster for this poetry festival
places the names *Tyskland* ("Germany" in Danish) and *Dänemark*
("Denmark" in German) opposite each other on a magenta
background, which is the color of love, freshness, and vibrancy,
highlighting the cultural history shared by the two countries.

Benny Anderssons Orkester ı 25AH Design Studio. Poster for summer concerts of traditional Swedish folk music. The key concepts of "music" are emphasized by using various shades of pink.

PANTONE 485 C

Kunstmuseum Wolfsburg
Hollerplatz 1
38440 Wolfsburg
Germany

T. +49 (0)5361 2669 0
F. +49 (0)5361 2669 11
info@kunstmuseum-wolfsburg.de
www.kunstmuseum-wolfsburg.de

Mo geschlossen
Di 11.00 bis 20.00 Uhr
Mi–So 11.00 bis 18.00 Uhr

Swiss Made⁺

Kunstmuseum Wolfsburg

Präzision und Wahnsinn

Positionen der Schweizer Kunst
von Hodler bis Hirschhorn

Max Bill	John M Armleder
Richard Paul Lohse	Hannah Villiger
Ferdinand Hodler	Urs Lüthi Beat Streuli
Alberto Giacometti	Markus Raetz
Ferdinand Hodler	Helmut Federle
Louis Soutter Adolf Wölfli	Martin Disler
Paul Klee	Silvia Bächli
Robert Müller	Roman Signer
Albert Anker	Dieter Roth Arnold Odermatt Eric Hattan
Robert Zünd	Steiner & Lenzlinger
Alexandre Calame	Balthasar Burkhard Cécile Wick
Ferdinand Hodler	Pipilotti Rist Christoph Draeger Ingeborg Lüscher
Ben Vautier	Christoph Büchel

03.03. - 24.06.2007

schweizer kulturstiftung
pro helvetia

Swiss Made ı Double Standards. This poster announces an exhibition
of Swiss art. The designers intentionally mixed red and white to
visually reinforce the Swiss identity and crowned "Swiss Made"
with the Swiss cross.

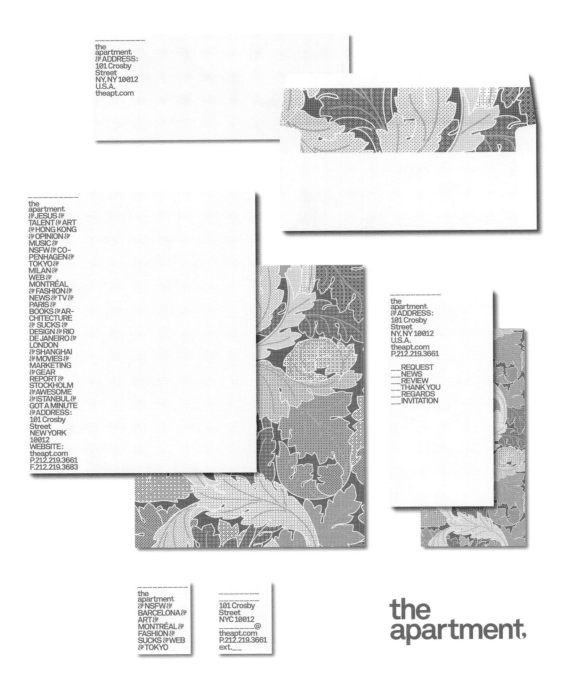

The Apartment I The Luxury of Protest. Design of the corporate identity and stationery items for the New York design studio The Apartment. The wallpaper design that can be seen in some items is a reproduction of the Acanthus wallpaper by William Morris.

Peace Still Works ı OhioGirl Design (Andy Mueller). In this illustration, designed for a T-shirt, the text printed in a negative format over the almost abstract image of a hand, making the international sign of peace (and victory), focuses the attention of the viewer on what is really important: the slogan.

Universidad Autónoma Metropolitana ı Félix Beltrán. The minimalist design of these posters by artist Félix Beltrán is strengthened by the use of a single color, by the choice of pure geometric shapes, and the use of a strict grid format. It is difficult to see how the design could be further simplified.

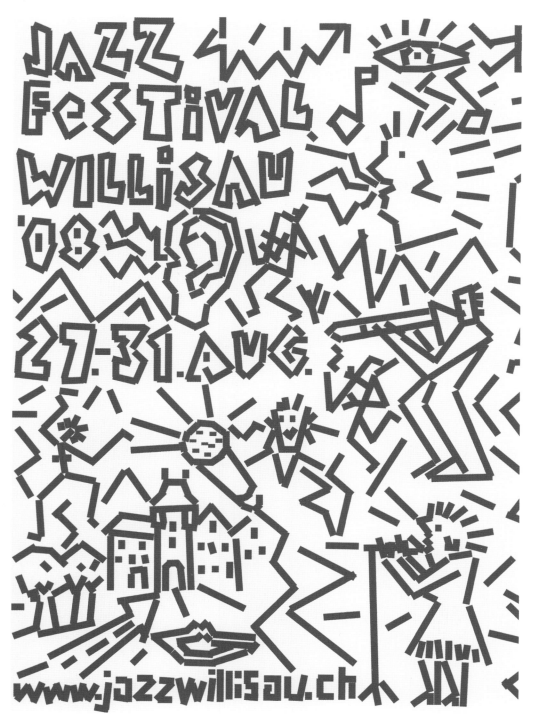

Jazz Festival Willisau I Niklaus Troxler. For the design of the poster for the Willisau Jazz Festival, Niklaus Troxler used fragments of tape to produce the various elements that can be seen here: the name of the festival, the website, the date, and the various pictorial elements.

Here is the bottom line for design: It is impossible to work with fewer colors. Demonstrating just how false this statement is, the following pages will show the reader dozens of examples of monochrome designs and their well-nigh infinite number of possibilities. Organized in order of the Pantone color matching system, the works in this section play with abstraction, fonts, black-and-white images, negatives, etc. And how can we measure the success of a monochrome design? Well, a good monochrome design is one in which the use of more colors would not add anything to the final result, but would instead detract from it. Not only have all the designers featured in the following pages created successful monochromatic designs, they have also redefined the bottom line.

DESIGNING WITH ONE COLOR

DESIGNING WITH ONE COLOR AND TWO COLORS
Copyright © 2011 by Harper Design and **maomao** publications

All rights reserved. No part of this book may be used or reproduced in any manner whatsoever, without written permission except in the case of brief quotations embodied in critical articles and reviews. For information, address Harper Design, 10 East 53rd Street, New York, NY 10022.

HarperCollins books may be purchased for educational, business, or sales promotional use. For information, please write: Special Markets Department, HarperCollins*Publishers*, 10 East 53rd Street, New York, NY 10022.

First Edition:
Published by **maomao** publications in 2011
Via Laietana, 32 4th fl., of. 104
08003 Barcelona, Spain
Tel.: +34 93 268 80 88
Fax: +34 93 317 42 08
www.maomaopublications.com

English language edition first published in 2011 by:
Harper Design
An Imprint of HarperCollins*Publishers*
10 East 53rd Street
New York, NY 10022
Tel.: (212) 207-7000
Fax: (212) 207-7654
harperdesign@harpercollins.com
www.harpercollins.com

Distributed throughout the world by:
HarperCollins*Publishers*
10 East 53rd Street
New York, NY 10022
Fax: (212) 207-7654

Publisher: Paco Asensio

Editorial Coordination: Anja Llorella Oriol

Editor: Maia Francisco

Introduction & Text: Maia Francisco, Cristian Campos

Translation: Cillero & de Motta

Art Direction: Emma Termes Parera

Layout: Maira Purman

Cover Design: Emma Termes Parera

ISBN: 978-0-06-200461-1

Library of Congress Control Number: 2010941621

Printed in Spain
First Printing, 2011

The PANTONE colors were specified by each designer and reflect how the projects were originally printed, but not how they have been reproduced in this book. The images in this book have been printed using the PANTONE COLOR BRIDGE® Coated guide which shows the best possible four-color process simulation on coated stock of the original solid PANTONE Color being identified above each image. Due to the printing process and paper stock variables, the colors may vary accordingly from the designer's initial projects.

PANTONE Colors displayed here may not match PANTONE-identified standards. For accurate PANTONE Color Standards, refer to current PANTONE Color Publications. To purchase or receive more information about PANTONE Products go to www.pantone.com. PANTONE® and other Pantone trademarks are the property of Pantone LLC. Portions © Pantone LLC, 2010. All rights reserved. Pantone's trademarks and copyrights used with the permission of Pantone under License Agreement with **maomao** Publications.

DESIGNING WITH ONE COLOR AND TWO COLORS

MAIA FRANCISCO

HARPER
DESIGN

An Imprint of HarperCollins Publishers

DESIGNING WITH ONE COLOR AND TWO COLORS

MAIA FRANCISCO